On Boys,

Boobs,

and Badass

Women

IT'S MESSY

IT'S MESSY

Amanda de Cadenet

HARPER WAVE

An Imprint of HarperCollins*Publishers*

IT'S MESSY. Copyright © 2017 by Amanda de Cadenet. All rights reserved. Printed in the United States of America. No part of this book may be used or reproduced in any manner whatsoever without written permission except in the case of brief quotations embodied in critical articles and reviews. For information, address HarperCollins Publishers, 195 Broadway, New York, NY 10007.

HarperCollins books may be purchased for educational, business, or sales promotional use. For information, please email the Special Markets Department at SPsales@harpercollins.com.

FIRST EDITION

Library of Congress Cataloging-in-Publication Data has been applied for.

ISBN 978-0-06-241245-4

17 18 19 20 21 LSC 10 9 8 7 6 5 4 3 2 1

For all the badass women in the world,
especially the ones who asked
me to write this book.
This is for you.

Contents

Introduction

I consider myself to be a relatively fearless woman. I've been riding motorbikes since I was six years old, hosting live TV since I was fifteen, and I gave birth to my first child at nineteen. But when Hillary Clinton walked toward me at her campaign headquarters at One Pierrepont Plaza in Brooklyn in January 2016, I momentarily lost my mind. A trickle of perspiration ran down between my boobs. My tongue got thick and dry, as if I'd smoked too much weed, and then my mind went blank. I couldn't remember my name . . . or her name . . . and what the hell was I supposed to call her again?

Secretary Clinton?

Hillary?

First Lady?

Suddenly, I felt far from fearless. My entire being was flooded with self-doubt.

What the fuck am I doing here?

I shouldn't have agreed to do this.

How could she *have agreed to do this?*

And how have I passed the Secret Service background check?

I was seconds away from interviewing one of the most powerful and fascinating women on earth. Love her or hate her, you have to admit the prospect of interviewing the woman who everyone thought was about to become the first female president of the United States is daunting. Besides the boob sweat and dry mouth, all I could think about were the illegal drugs I'd done twenty years ago, the time I'd spent locked up in juvie as a teenage runaway (more on that soon), and the expired driver's license I'd been using for the last six months. I was sure that, at any moment, a member of her staff would discover these marks on my record and I'd be embarrassingly removed by her security detail.

Fear, my old friend, was talking to me loud and clear.

But to my surprise, the former secretary of state casually approached me, looking very Hillz in an excellent

red-coat-and-black-pant suit, and gave me a big smile. "Hi, Amanda."

Of course, being a superpro, she knew my name. Hillz extended her hand, and as soon as we locked eyes, my fear and anxiety immediately evaporated. In that moment, I remembered exactly how I had earned the right to conduct this interview: I had consistently worked my ass off interviewing people since I was fifteen years old, and I had overcome endless adversity and personal challenges. All because I held on to the belief that, one day, I would be able to hold my own with the lady who was now standing in front of me.

When I started my talk show, *The Conversation*, from my living room six years ago, my vision was to facilitate honest conversations with respected women that would inspire and empower other women to live their lives fearlessly. I was fortunate that some of the most intelligent, iconic, insightful women on the planet—ladies like Jane Fonda, Lady Gaga, Gwyneth Paltrow, Arianna Huffington, Sarah Silverman, and Alicia Keys—agreed to sit on my couch and talk to me about their loves, losses, successes, and failures. For the last forty-five years, Barbara Walters had cornered the market on long-form interviews, and I felt that as she was fast approaching her eighties,

maybe, just maybe it was time for another woman to be allowed into the one-on-one interview realm. My intention wasn't to make guests cry, which often happened; I just wanted to create a safe space where women could share their truths. It's in those unfiltered and vulnerable moments you realize that we all have more in common than we might think, that we've all been through *stuff*, and that every female has a story to tell, whether she's won an Oscar or a two-dollar scratch-off card at 7-Eleven.

My own story is shocking, funny, tragic, lucky as fuck, and, of course, messy. Very, very messy. Just based on my tricky childhood, I shouldn't have amounted to much. This might sound strange coming from the daughter of a race car driver dad and a model mom. Those who knew our family in London probably thought I had it made, as I was born into a very privileged situation, no question about it. But privilege doesn't protect you from everything. Especially if you have a vagina.

I believe now, more than ever, that anyone who identifies as being female will, at some point, face one or more of the following life challenges: gender discrimination, body anxiety, unwanted sexual attention or advances, various forms of addiction, and heartbreak. There is not a career, relationship, or diet that makes you exempt from

these issues. If there were, I'm pretty sure I would have discovered it long ago.

Let me say this now, though: this is not a self-help book. It is not a diary. I haven't kept one of those since I was a teenager, when a tabloid stole it and published excerpts as if it were a Jackie Collins novel. I'm not a licensed therapist. My only credentials are my life experiences, and there are a whole lot of them, both incredible and very messy, that's for sure.

I'm hoping that in sharing my stories with you, as my guests do on *The Conversation*, I might offer you some experiential insights. I've been through the shitty—slut shaming, cheating, divorce, sexual abuse, domestic violence, going broke—the fantastic—exciting career, passionate love, marriage, and beautiful children—and the ugly—betrayal, health scares, body issues, and friendships gone bad. *It's Messy* is a collection of very personal essays, written in bits and pieces between parenting my three kids, putting the time in to keep my marriage going strong, learning to compromise and communicate more than I thought possible, and working three jobs.

I'm not always happily married, but I have been with the same man for sixteen years. I am not a blissed-out

mother, but I am extremely proud of my twenty-five-year-old daughter, Atlanta, and my delicious ten-year-old twins, Ella and Silvan. I'm not the CEO of a Fortune 500 company, but I am the founder and CEO of my own media company, which I've built from scratch and worked my ass off to grow exponentially year after year.

Each chapter in this book is inspired by questions posed by the awesome women and girls in my digital community. They were kind enough to let me know what they wanted me to write about, and I have obliged (for the most part). From boobs, babies, and best friends to bank accounts, beauty, and boys, I'm hoping that sharing some of the good, bad, and ugly from my life will inspire you to explore what makes you tick, and make you feel less alone on your own unique journey.

Writing this book has been, hands down, one of the hardest things I've ever done. My friends who are writers assured me that it would be like childbirth—that I wouldn't remember the pain once the book was published. But I think I will. This has been one hell of an experience. Not only has it been overwhelming and terrifying, but it has also made me recognize that I've survived some crazy-ass shit.

Heads up. This book does not need to be read in se-

quence. If you just want to identify with someone about love and heartbreak, head to chapter 3. If you're in the chaos of new motherhood, turn to chapter 8. Or if it's the morning after a one-night stand, you may want to turn straight to chapter 4. *It's Messy* is a book I hope you will come back to over the years, as a reminder that you are not flawed without hope. Shit happens to everyone. And you and I, and every other woman out there, should not have to do it alone. Even when it's super goddamn messy.

Life According to Little Amanda

A lot of people thought I was destined for a life of ease the moment I came into the world. But trust me, even privileged girls can go through the wringer.

My father, Alain de Cadenet, was a successful Le Mans race car driver and my mother, Anna, was a model turned full-time mom turned interior designer. I grew up in Chelsea, a posh London neighborhood, with Jane Birkin and Mick Jagger as our neighbors. No big deal, just how it was on our block. My handsome dad was the guy too many of my school friends had a crush on, and I hear he reciprocated those feelings with one of my friends;

she was over the age of consent, but still. My super foxy mom, Anna de Cadenet, would pick me up from school in her sporty BMW, dressed to impress in Thierry Mugler high heels and hot-pink '80s spandex. I remember people staring at my parents, and staring at me and my little brother, Alexander. We were apparently a family that people liked to look at. My mother would say, "Amanda, people will stare at you all your life because you are pretty. But it doesn't mean you're special." Because the outsides drew attention, she never let my brother and I forget that it was the kind of people we were on the inside that really counted, and I still believe that today.

As a young kid, I, Little Amanda, was full of confidence and genuine curiosity about the world. I've got photos of myself roller-skating up my street wearing faded dark-blue corduroy pants, odd socks, and a bright-colored, stripy roll-neck. The smile on my face is one of pure joy. I've come back to this image many, many times when I need to remind myself that I was a relatively happy child . . . until I wasn't anymore, which seemed to coincide with me turning eleven, when my parents separated and my world started to fall apart. As is common when parents split, I continued living with my mom. My parents divorced for reasons still not entirely known to me, and

I've since made peace with the fact that I may never know the truth. My father moved into the home of his weird friend, whom I accidentally saw naked on more than one occasion when I was visiting my dad. Needless to say, I avoided going there as much as possible, and the image of this guy's gigantic penis is, unfortunately for me, seared into the early memory bank of my prefrontal cortex.

I deeply loved my parents, but during their divorce, I felt completely abandoned and pulled in two directions at once. My mom said my dad didn't want to spend time with us. My dad said my mom refused to let him see my brother and me. It was one of those "he said, she said" situations that to this day has never resolved itself. I don't have many memories from that time, except an overwhelming feeling of hopelessness and loss. I felt completely alone in the world and wondered who would take care of me, because I didn't feel that anyone really was.

When I was fifteen I took matters into my own hands and I did what I thought was the best thing for me: I moved out of my mother's home. I packed a trash bag full of clothes, walked to the subway, and headed to my best friend's house. I secretly slept under the desk in her bedroom until her mom discovered me and told me to go home, but that just wasn't an option for me anymore. I

was convinced that if I was to survive, I had to start creating a world of my own, one that didn't require me to rely on anyone but myself. At age fifteen, out of necessity, I became completely self-reliant.

Instead of going home, I moved into a very proper squat in Soho with a group of teen runaways like me. The apartment was one short block away from the Mud Club, the Limelight, and the rest of the scuzzy clubs I had begun to frequent. Bizarrely, it never seemed much of a problem to the bouncers, bartenders, or managers that I was so young. My face looked fifteen, but I had the body of a twenty-year-old, which gained me access to places I had no business being.

It was an extremely confusing time for me; the tumultuous thoughts in my head became unbearable and almost torturous. I was desperately trying to stay alive when it felt as if my mind was trying to kill me. It was as though I was constantly playing a chess game in my mind, analyzing the outcome of every possible move before deciding which one to choose.

It's no surprise that I found ways to turn down the volume of the endlessly loud committee of voices in my brain constantly shouting: "Amanda, you will never amount to

anything. You are nothing, useless. No one wants you, not even your own parents. Amanda, no one will even notice if you're gone. If you do enough drugs, you can easily slip away in your sleep."

Slipping away was a strong possibility. I'd spend most nights hanging out in sleazy clubs, doing drugs until the sun came up with whoever would give them to me—mostly other teen girls, lustful old men, and nightclub promoters. It took me a while to figure out the obvious: there is always someone willing to share their drugs with a girl they think they can fuck at the end of the night. But I wasn't about to be *that* girl. I knew that was a road straight to nowhere. Even so, pretty quickly, without ever spending a dollar, I managed to develop a nasty drug problem.

Night after night, my last thought before I passed out into a pill-induced slumber was, *I wonder if I'll ever wake up.* Only to wake up the next afternoon and start all over again. The vicious cycle of addiction is not discerning; it doesn't care that I am someone's daughter, that I am only fifteen, that I am smart, kind, and that I need serious help. My addiction wanted me dead, and more than a few times, I almost obliged.

One morning at six a.m., after being up all night getting high, I experienced what continues to be one of the most traumatic yet defining moments of my life.

I was lying on a mattress in the attic of the squat wearing nothing but my socks, trying to get my mind to stop racing after a night of drug use, when I heard a huge crash downstairs. The sound of wood splintering, then men's voices getting closer and closer, and the sound of heavy-soled shoes rushing up the stairs into the bedroom where I was by now sitting up trying to make sense of the noise. It all happened so quickly. A whole lot of policemen burst into the room; someone shone a bright light into my face, then threw a rough blanket around me to cover my naked body; and before I could register what was happening, I was bundled down the stairs, my hands handcuffed behind my back, and literally thrown into the back of a van.

What the hell just happened?

My brain just could not compute.

I was sleep deprived, high, and naked, being taken to an unknown place in an unknown vehicle.

It never occurred to me that running away as a minor is illegal. My parents, at a loss over how to parent me, had

reported me as a missing child, like the kind you see on the side of milk cartons. Except girls like me weren't supposed to end up missing.

I was taken to the local police precinct where I was questioned about my activities, especially relating to prostitution, which was news to me. I had gotten up to some illegal activities, but this didn't happen to be one of them.

The way I was interrogated by the male cops at the police station was nothing less than misogynistic and terrifying. They pulled my bras and underwear from my plastic bag of personal belongings, carefully examining them as if they held some clues to confirm their prostitution suspicions. The cops tried every manipulative tactic to get me to admit to selling my body, but I had nothing to confess other than I did have sex at age fifteen, which is considered an illegal activity. That admission got me placed on the "at risk" list, a list reserved for children who are victims of either sexual abuse or assault.

In retrospect, it's insane to me that I was added to such a serious list. As I was soon to find out, there were kids who needed to be on it way more than me, but weren't given the protection from social services that they so badly needed and deserved.

I was not formally arrested, but was held at the police station for the longest twenty-four hours of my life. I wanted out of the small windowless cell; I had spent the last day and night inside. I was hitting the point of exhaustion and consumed by terror about what would happen to me next. Eventually I was ushered out of the cell into an office, where I was informed I was being made a ward of the court, meaning the government was now my legal guardian. I was then taken to White City Children's Home, a juvenile detention center in West London where I was told I would be staying possibly until I turned eighteen, or until I could prove that I had "changed my ways."

I had no idea what that meant, but I knew it meant I would not be myself in any way, shape, or form.

★ ★ ★

Believe it or not, living in a children's home and essentially being the property of the government gave me a skill set that served me incredibly well throughout my life. For one thing, I learned that people's circumstances are often not the best indicators of who they really are. Sometimes bad things happen to good people. And if I looked for the similarities with others rather than the

differences, I found I had a lot more in common with most people.

In juvie, I quickly learned there was no such thing as privacy or safety. I kept my money—what little I had of it—shoved down the side of my lace-up army boot, waiting for the day I would be released back into the world, when I would need my fifty bucks to get wherever I was going.

During my stint at juvie, I made some friends but hung out with one girl more than the others. She was welcoming and kind, and taught me how to survive inside the system.

I had no idea she was a sex worker taking clients after school and that her pimp was a boy in juvie with us. I had been exposed to prostitution years earlier by my babysitter, but her confession shocked the shit out of me. Although nothing on the surface was similar about our respective lives, I found we did have a few significant things in common. We were both survivors of sexual assault, we both had low self-esteem, and we both received validation from being desired by men. My relationship with her was the first of many friendships where our wounds would deeply connect us.

In juvie, I was exposed to a whole new world that I had no idea existed: guns and drug dealing on a semiprofessional level, prostitution as a means of survival, and violence as a way of communication. I found this last one out the hard way one evening whilst taking a bath, when a group of boys kicked the door down (just to scare me, they said). And then there was another memorable time a boy burst into my room and set fire to my bed while I was in it. I escaped unscathed, but this was certainly not the life I had planned for Little Amanda.

Fast-forward a few decades to my Hillary Clinton interview on *The Conversation*, when she reminded me that children need just one person to believe in them in order to reach their potential. She had no idea how much I knew that to be true. Many of the kids in juvie didn't have that one person, and at the time it felt as though I didn't, either.

The bed-burning incident was apparently alarming, even to the hardened juvie staff, and they decided I was in more danger inside the home than out. To my monumental relief and after many months of juvie living, I was released back to the care of my mother and found myself living at the home I had wanted to get away from six months earlier.

IT'S MESSY

My mother was so scared I would disappear again that I was only allowed out of the house to go for walks around the block with our family dog. I had the added annoyance of being followed by paparazzi wherever I went, as by this time I was dream fodder for the tabloids. A teen runaway from a posh family. The UK loves a good "girl gone wrong" story, especially if it involves privilege—and I provided an endless supply of entertainment. The paparazzi followed me day and night, documenting my every move, which was pretty limited at the time, but nonetheless the constant attention and public analysis of my life was a living nightmare. When I eventually went back to school, this time to a public school called Holland Park Comprehensive, I was forced to eat my lunch in the middle of the cafeteria because the paparazzi were always at the windows looking for me. This was no way for a fifteen-year-old girl to live, and that period of my life caused severe trauma that took me, no joke, the next twenty years to recover from.

It was really hard to go back to a family that, as I saw it, had given me up to the government, and I wanted to get out of my mom's house as soon as I could. It's clear to me why so many women stay in less than ideal situations, just for a roof over their heads. During this time, I

learned firsthand that financial security means freedom, and boy, did I take note.

If I wanted to make my own choices in life, then Little Amanda would have to learn how to provide for herself, both emotionally and financially. That continues to be my driving force all these years later.

2.

Getting a Job That Doesn't Suck—Even If You Went to Juvie and Left School at Fifteen

I began working odd jobs as a teenager—quite literally. My first paid gig happened before the whole juvie situation. I was hired to be a model for Clarins body lotion, my first big modeling moment, which featured a picture of me lying facedown on a bed, with my naked body covered in a swirl of body cream, as if someone had jerked off in a perfect circle onto my back. Happily, my modeling

career got another chance after that anticlimactic false start. My next opportunity came when I was booked for a swimsuit shoot on the island of Capri, for an Italian fashion label called Sicily. I loved Italian food and boys, so I was really optimistic about this trip.

After taking a plane and a boat from London, I arrived on the island of Capri and checked in at the super chic hotel. I got myself settled in, unpacked, searched for the room service, and had some pasta and ice cream sent up to my room, which was delivered by the most handsome room service guy I had ever seen. I thought about inviting him in but remembered my ungodly early call time of 6:00 a.m., so I passed on him and got a good night's sleep.

The next morning I ate a full breakfast complete with eggs, pastries, and some super strong coffee to wake myself up, and got to the set excited and ready to go. My first outfit was an '80s *Baywatch*-style white one-piece that I felt really foxy wearing.

As I stood in front of the crew of thirty people in my *Baywatch* attire for ten minutes, twenty minutes, eventually my confidence was replaced with crippling insecurity and I began to not feel so hot anymore. Yet again I got a familiar feeling that something wasn't quite right.

Sure enough, the art director, photographer, or someone in charge came up to me and said, "Thank you, Amanda, you can go back to your room now."

The negative self-talk started right away.

You shouldn't have eaten that pasta, your stomach is sticking out. You aren't model material, they made a big mistake hiring you. You will never amount to much, you will never succeed, you may as well give up.

My second opportunity to become a supermodel had gone horribly wrong.

Lesson 1: Getting fired is part of succeeding

My booking agent would later tell me the client felt I was too "shapely" for the look they were going for. But I already knew what they thought—I didn't need him to tell me. My stint in juvie had taught me how to read a room like a pro. And the look on their faces when I walked out in that white *Baywatch* swimsuit told me everything I needed to know. In their minds, I was too fat to be in their fashion campaign. My already fragile self-esteem took yet another hit. So I did what I knew how to do best: I went back to my hotel room, got into bed, and ordered cake and more ice cream, but sadly it was delivered by a not-so-cute room service guy this time.

I lay on the bed staring at the ceiling with tears streaming endlessly down my face, my chances of financially supporting myself crushed once again. I thought about the words a wise woman once told me, "If you can find a job you love, then it isn't a job." I wish I could remember who said it because I've lived by that philosophy ever since. From the moment I realized I needed to financially provide for myself, I have tried to find a way to turn what I'm passionate about into a sustainable career and have consistently asked myself, "How can I earn enough money to support myself and be of service to my maximum capacity?"

What I was doing wasn't working, and it was time to rethink the game plan.

<p style="text-align:center">★ ★ ★</p>

So if I wasn't going to be a supermodel, what could I do?

I applied for any job I could. My local pizza place called Pucci's Pizzeria, a clothing store, Snappy Snaps the one-hour photo lab. No one would hire me, after all I was fifteen, had no work experience, and no obvious skill set. One night I met a guy in a bar (but of course) who told me about a new late-night TV show called *The Word* that

was looking for a host. At the time, the UK had only four channels and certainly nothing that appealed to a fifteen-year-old girl like me. I had never thought about being on TV before, but I needed a job, and my time in juvie had taught me how to talk to anyone about anything. So I showed up for the audition and, to my complete surprise, five days later was offered the job. Little did I know that all the rejection from previous jobs had led me to the exact place I needed to be, and that my life was about to drastically change.

From the first show, my gig was doing the live interviews. I'm going to own this one and admit that even at age fifteen I enjoyed my job and was damn good at it. I had the perfect amount of fearlessness, and it helped that I usually did my interviews drunk. What better way to handle the terror of hosting live TV in front of over five million viewers?

When *The Word* became an overnight success, I did, as well.

I think there needs to be a handbook on how to handle the biggest mindfuck of all: being accepted, admired, and adored just because you're suddenly, blazingly famous. I had inherited my earlier fame through circumstance, and

being a teenager hosting a now infamous late-night TV show made me a household name on another level.

I was painfully young, and my heart and soul were ill-equipped to handle the attention of so many people and the unrelenting viciousness of the British media. Yet my emotional pain was so great that all the attention distracted me in a most welcome way. Being treated like you're special feels great at first, especially for someone like me, who felt invisible for so long. But without some professional support or a secure family unit to lean on, fame completely distorted my perception of myself, which took years to rightsize.

<p style="text-align:center">★ ★ ★</p>

People don't believe me when I say being famous did nothing to contribute to my happiness. According to a recent study, fame is the number one most desirable job for teen girls.

Sadly, we're living in an age when self-promotion is constant, and the number of clicks, views, subscribers, and likes on social media accounts is a barometer not only of popularity but also of self-worth.

I'm not judging it, but it's just smoke and mirrors. It's

not real. Unlimited amounts of attention appear to be the cure, filling the gaps and healing the heart, but from my own experience, I can say that fame is just a temporary Band-Aid covering a much deeper wound. Real and lasting self-worth comes from consciously creating a life that you've earned and that is authentically yours. Your life doesn't disappear when you're unfollowed.

★ ★ ★

Six months after I got hired on *The Word* and started populating every tabloid on a daily basis, I sat next to John Taylor, the bass player for Duran Duran, at a matinee play. I was completely unaware of who he was. Maybe it was the twelve-year age gap, or that I was into punk, not pop music. He made me laugh and immediately struck me as being a kind man, and I was ready for some more kindness in my life.

We started dating, and the tabloid media had a field day. They reported us as being together from that very first meeting. From that moment onward, every street we walked, every party we attended, every art opening we went to, every public kiss we exchanged became daily tabloid fodder and material for cultural commentary. You

can imagine the reaction when I got pregnant with our daughter and we then married, when I was the ripe old age of nineteen.

After two years of hosting *The Word* then becoming a mother, I realized my job and the lifestyle that came with it just didn't fit with who I was anymore, and most of all, who I aspired to be. At the time, I was getting offers for my own TV show, but I just couldn't bring myself to say yes. On the surface it seemed like a no-brainer—who wouldn't want their own TV show?—but I was exhausted from the insanely fast-paced life I'd been living, and from the self-obsession that went with having that much attention focused on me at such a young age.

I admitted to myself that, although I was making good money, I could not have been more miserable. This was the first time I got an inkling that happiness truly is an inside job.

Although seemingly big on the outside, my life had become extremely claustrophobic. I felt as if I were living in a tiny glass goldfish bowl, so I quit my desirable job, packed a suitcase (literally, a single suitcase), left my big London brownstone with food in the fridge and laundry in the hamper, and split to Los Angeles with baby and hubby in tow.

People thought I was crazy. No one could understand why I would quit my cushy life. But I knew that if I didn't leave my life in London, it would quite literally be the death of me.

Lesson 2: Take risks

Our new life in Los Angeles was quite a culture shock and couldn't have been more different from what I left behind in London. We rented a one-bedroom guesthouse deep in Laurel Canyon, where I knew no one. I didn't venture far from home, staying within a two-mile radius most of the time. I went from driving a new Porsche to buying a two-thousand-dollar used orange Jeep Cherokee that broke down on a weekly basis. I was only twenty, and for the first time, my life felt more age appropriate, more authentic, and, most important, it was MINE.

Despite having been paid well for my work on *The Word*, I had not saved any money, which was a big mistake. John obviously had savings from Duran Duran, which relieved me of immediate financial worry. Not having to obsess over money was a huge luxury that is not lost on me and allowed me to focus 100 percent on mothering Atlanta for the first two years of her life. But by 1995 it was sadly clear to me that my marriage was falling

apart and was not going to survive. Despite being terrified about how I was going to cope, living in a country where I knew very few people and having little financial security, I knew separating was the right thing for me to do.

I didn't exactly have a lot of job skills, and my work history was unusual to say the least. I had been taking acting classes, which I loved, but—aside from getting a small role in the film *Four Rooms*—I really hated being a struggling actress. I was offered only the most clichéd roles: basically anything that required me to show my boobs and play dumb, which has been the mandate for many female roles until very, very recently. Part of the reason I'd left London for LA was that I wanted to live a genuine life, and I didn't even know what that was yet, but I knew I didn't want to pretend to be anyone else, especially someone's stereotypical fantasy. I needed to spend more time discovering what my own reality was. But this realization did nothing to change the facts. I was still a single mom who could not survive on child support alone. I needed and wanted to work.

I thought back on the lesson I learned after the Italian swimsuit shoot, that the best job was one that honored my truth, my skills, and my passions. But how do you get to your truth? How do you identify your strengths and tal-

ents and then make a career out of those things? I started by asking myself some serious questions:

What can I contribute to the world?

What is unique about me?

What brings me joy?

What steps do I need to take to help myself achieve this goal?

After I was able to answer these simple questions, I literally drew myself a road map. I'm a firm believer that if you don't have a clear goal in mind, you can't expect the universe to support you in reaching it. Even as I write this, I have sticky notes listing my dreams and aspirations stuck on the wall over my desk. One of the notes reads, "Write a book." And never mind that it has taken me five years to write, here I am actualizing that dream.

<p align="center">★ ★ ★</p>

From the moment Atlanta was born, I was obsessed with documenting her life with my camera. I know what I'm about to say is shockingly codependent and maybe disappointing, but for many years the men in my life were largely responsible for inspiring my interests and hobbies. Until I was about thirty, if a boy was interested in something, I'd fully educate myself on that subject. And over

the years I have learned a lot about everything, from flying planes to rock climbing, from basketball teams to horror movies, none of which I have any interest in but I learned about as a way to connect with whatever dude I was into.

However I came to love it, photography was a medium in which I could express myself, without anyone else's permission, whenever and however I wanted. I was sick of needing other peoples' permission to create, and photography allowed me to tell stories and not be a subject of them, which was such a relief to me.

Lesson 3: Ask people who know more than you lots of questions

I was enamored with photography and educated myself in every way I could. I went to museums and galleries, and spent hours at bookstores reading books and magazines and studying the images and words of people I admired. I fell in love with reportage photographers like Diane Arbus, Robert Frank, Mary Ellen Mark, Corinne Day, and Weegee. Perhaps because I was searching for the truth about the world, their images struck me as searingly honest, and that resonated with me.

Photography made my heart happy and challenged my

perception of the world. Once I committed to pursuing a career as a photographer, I was relentless. I made a conscious choice to ignore the very loud critical voice in my head telling me I couldn't possibly be a real photographer, despite having been told that by so many people. I can't tell you how many times I was literally laughed at and told I'd never succeed. And if I thought I'd experienced sexism in front of the camera, it was even more rampant, though covert, in the photography industry, which to this day is still dominated by men. Whenever I'm hired for a shoot, I ask the art directors how many female photographers they hire. The answer is usually zero. Sadly it's the same in many other creative industries, too. The sexism and systemic patriarchy built into the fabric of our world render the desirable professions—those that bring satisfaction, a good income, and acclaim—largely as the domain of men. Which is why I'm so hell-bent on changing the ratio.

For years I couldn't get a job as a photographer that didn't involve me being *in* the image somehow. But I refused to give up, because I knew what I was capable of. I had survived a lot and had already been successful once, so I knew that if I worked hard, then surely I could do this—even if I did have failures along the way. I have yet

to meet a successful person who hasn't been doubted and failed a lot. Arianna Huffington once told me, "Over ninety percent of the people, including the people who loved me, thought the *Huffington Post* wasn't going to succeed." Knowing this has given me much comfort over the years.

I remember the day I finally allowed myself to own my new professional title. I was in the park with my kid, and someone asked me, "What do you do?"

Without a moment's hesitation I said, "I'm a photographer."

In a movie, that moment would have been accompanied by music and a montage of kick-ass images. But the fact is I had to keep working really hard to finally be given real opportunities. People seemed to love taking the piss out of me, and even after I started landing respectable gigs, misogynistic art directors felt free to openly disrespect me and my work. One looked at my portfolio, aimlessly flipping through until he paused on a cover photo of Keanu Reeves that I'd shot for *Vogue Hommes*. (By the way, I was the ONLY female photographer in that entire issue.) In the picture he's standing in a swimming pool wearing a brown shirt, his hair wet, leaning toward the camera, looking insanely hot.

"Why do you think your pictures are any good." It was a demand, not a question.

"You want me to quantify why I think my work is any good?" I said. He was so up his own ass, this guy.

"This is not a fashion picture," he said.

"I never said it was."

And that was that.

We never did work together, which is fine by me—this is the guy who ended up being partially responsible for the photo of eighteen-year-old Kylie Jenner bare-assed in bondage gear in a wheelchair.

I don't want to forget the many badass, talented male photographers, specifically Mario Sorrenti and Glen Luchford, who whilst photographing me were gracious enough to put up with my endless questioning about everything from film speeds to lighting to photo editing software in my quest to learn as much as I could. They taught me so much and gave me huge encouragement and guidance on my path to actualizing my desire to be a professional photographer.

★　　★　　★

Because I've been highly sexualized—and, in all fairness, I sexualized myself, too—with my photography I was

committed to showing another side of women, one that allowed for sensuality but also portrayed them as beautiful and strong.

My years of interviewing people on live TV served me well as a photographer. I could connect with my subjects quickly and in an authentic way, and through that connection achieve an intimate moment and image. From years of being the subject of the picture, I knew how to handle people who were in front of my camera, and it showed in my work.

My subjects felt my intention whether they realized it or not. They saw I was not there to exploit them, to tell a story about them I'd already written in my head. My approach was, and is, "Who are you? I just want to see who you really are."

After years, and I mean over five *years*, of trudging along, my career started to grow. I began to shoot for publications like *Vanity Fair*, *Elle*, *Allure*, and the *New York Times*. Eventually, I became the youngest woman ever to shoot a *Vogue* cover and in 2005 published a book of some of my favorite pictures from my life, called *Rare Birds*.

But my photography career is still not what I know it can be, and not because my work isn't strong enough, but

simply because it just got too hard to keep fighting for work in an industry that is not set up for females to succeed.

<p align="center">★ ★ ★</p>

I'm still shooting pictures, although my time is taken up with other jobs that also don't suck. (More about those later.) I have learned, often the hard way, that it's possible to apply your life experiences—even traumatic ones—into work you don't just like, but love. The kind of work you're excited to do when you wake up in the morning. You must remember this: No matter how bad it looks and no matter how awful it is at the time, no matter what you've been through, there will come a time when you will be able to use that experience for something positive. Because of my life experiences, I've been given the gift of insight and empathy, allowing me to connect with people from the heart. I can listen to them, and I can hear them. I am able to see the beauty and the humanity in the person in front of me. That is one of the many blessings of everything I've lived through and one of the reasons I'm able to interview people in the depth that I do.

3.

Love, Obsession, and
How to Tell the Difference

═══════════════════════════

I have always known that if anything would kill me, it would be boys.

While I was blessed with outrageous luck in many areas, this is my weak point, my Achilles' heel, my cross to bear. And if you're surprised to hear that, here is a little story for you.

★ ★ ★

I must stop checking my messages. I dialed my own number and listened to my voice, a voice that hid my desperation.

I sounded calm and assured. "Hi, this is Amanda, please leave a message, thank you."

What it really should have said was "Hi, this is Amanda. If you're not the boy I am obsessed with, don't waste my goddamn time by leaving a message. Just hang up because I'll never call you back if you aren't HIM."

This has been the story of my life since I was a little girl. I've spent God knows how many hours waiting for whatever HIM of the moment to make me feel okay, to grant me some peace of mind, or even to just break up with me and make the torture end.

When I think back on my life experiences, it's always through the lens of my relationships with men. Each one a chapter. In the same way music or fashion mark a moment in one's life, the objects of my obsession annotate the years for me.

Starting with Rob, who was my first kiss, age fourteen. Augustine I lost my virginity to, age fifteen. I still can't believe my first time was with a dude called Augustine. He played bass in the school band and thus started my habit of dating boys in bands.

There were a few guys in the two years between Augustine, the school-band bass player, and John, the bass player in Duran Duran who became my first husband.

There were guys who, the moment I met them, I knew would break my heart. Each and every time something inside warned me, "Run away while you still can!" But it's just not my nature to say no to some dangerous intrigue, and life would be so boring if I always played it safe.

Which brings me back to that moment. Checking my messages obsessively, waiting for the phone to ring. This particular boy in a band was on tour on the other side of the country. The after show party, the whiskey, the coke . . . and I'm still expecting him to call. I believed that with enough focus I could will that phone to ring and, by the sheer power of my fantasy, everything would be okay.

Then the phone rang, validating my delusional sense of self. *I've willed a miracle.*

The moment he said "hey" I felt my heart booming in my chest. I could tell by his tone that I didn't want to hear what he had to say.

"I have something to tell you. You're not going to be very pleased with me, but I have to tell you the truth. I slept with someone else last night. Actually two someone elses. I'm really sorry."

Nausea hit me hard. I tried to catch my breath before the tears overwhelmed me.

"Why did you do that?" I asked pathetically.

"I just wanted to, it was something I wanted to do."

"Didn't you think about how this would affect me?"

"Well, yes, but I wanted to do it anyway."

"You are such a cunt."

"I'm sorry, but you should still come to New York, you can stay with me if you want, we just shouldn't date anymore."

I hurled my cell phone hard against the wall.

What kind of low-self-esteem girl did he think I was? *I can still come and stay with him, just as "friends." What a jerk.*

After I was done howling, I retrieved my mildy damaged phone (those protective covers DO come in handy), held it up to my ear to make sure it still worked, and booked the first available direct flight to New York.

A sad, but true fact.

On my way to the airport, I asked the driver to pull over at the 7-Eleven so I could buy a pack of cigarettes and break my firm no-smoking rule. I smoked the whole way to LAX between fits of hysterical sobbing. Having made it onto the plane, I curled up beneath a thin polyester airline blanket and cried during the entire flight.

My mind obsessively played out the confrontation I was about to have.

I considered which approach I should take—angry girl, hurt girl, crying girl, or maybe "you can't hurt me because I never really cared" girl?

When I wasn't plotting my strategy, I was berating myself. What in the hell was wrong with me?

Why was I flying across the country?

So that I could be crushed in person?

No girl with any self-esteem would be on this plane right now. From beneath my blanket, I heard a voice say: "Miss, are you okay?"

I poked my head out, tears streaming down my face.

"Actually, no . . . I'm not okay. My boyfriend just cheated on me with not one but two girls and . . . I'm on my way to see him." The flight attendant looked at me with pity, and I stuck my head back into the blanket cave and continued to weep.

After what seemed like an eternity, the plane landed. I gathered my scattered belongings and walked through JFK looking for a ladies' bathroom. After all, I had to look as good as I could, then maybe he would realize what a mistake he'd made, right?

But just thinking about my predicament made me start to cry again. My carefully applied makeup began to run, leaving big black streaks down my face. A desirable look

at one time, but not exactly the look I'd hoped for at this moment.

I took a cab to his place, a shitty fifth-floor walk-up in the East Village, which he shared with his coke fiend of a roommate, who also had a passion for fucking super curvy girls preferably in pairs, which seemed to be a theme in this friend group. I had been dating the guy for three months, and this was the first time I'd been to his apartment. He'd said it was a dump and he was embarrassed for me to see it. Rightly so, by the way. Calling it a dump was an understatement.

I stared out the cab window at the passing New York sights. I was exhausted, all cried out. I'd just flown across the country, yet again powered by my unquenchable obsession to be loved and desired.

<p style="text-align:center">★ ★ ★</p>

Does this story sound familiar at all and make you feel just a little bit queasy?

Worry not, as most of us have, at some point, been completely and utterly obsessed with another person, and been convinced it was love. How could a feeling so powerful, one that made your heart pound so hard and your

vagina feel so alive, and that consumed your every waking moment, be anything *but* love?

I hate to be the one to break the bad news, but you know that feeling as if you've lost your mind over a lover, as if being with them is better than the best drug you've ever taken, as if you won't survive without them? That isn't regular old love. It's love with a little something extra, commonly known as Love Addiction.

If you're a woman, you likely already have to battle against the "crazy girlfriend" stereotype, so admitting that you are love addicted is not easy. There's some major shame around it, but rest assured that many women I know have experienced it. I'd argue that love addiction is at least as common as alcoholism and often hides behind other addictions so it can be harder to spot. And to anyone who thinks the term *love addiction* is just some stupid pseudotherapeutic lingo—I'm here to tell you it is very real and has beaten my ass to a bloody pulp too many times to remember.

What does love addiction feel like? For me it's a vise-like grip of making someone else my everything. There's a fine line between passion and obsession. When you're in addict mode, you're obsessive and truly not in your right

mind. You think about your "beloved" all the time, ruminating on ways to get them to love you as much as you love them and to stay with you forever. Your entire life revolves around this "love," and you feel as if you literally could not live without that person.

* * *

Why do so many women find themselves love addicted?

Here's my theory: Think about the fairy tales so many of us grew up with. Until Prince Charming shows up and makes out with an unconscious and unconsenting Sleeping Beauty, she's not even awake. In virtually every film marketed to kids, there's some sort of flirtation or love interest or crush or unrequited love between the male and female leads. And it's generally the girl who's dreaming and scheming about how to make the boy notice her and fall in love with her, not the other way around. From a young age we're programmed to view this behavior as "romantic" when in fact "codependent" is a more realistic description.

An author whose books I love, biological anthropologist Helen Fisher has found in her own extensive research that what we often think of as romantic love is in fact an addiction that forms around attachment issues. Meaning: if you grew up with caretakers who were not present, you

will constantly be seeking a deep and sincere connection to fulfill your unmet childhood attachment need.

And sorry to say, if your primary caretakers were in a dysfunctional relationship, that relationship is likely your model for love relationships, and every time you meet someone who reminds you of what you grew up with, that's the person you'll go for.

In my case, there were many boxes easily ticked.

I had the perfect childhood for some major dysfunction in the love department.

Some other telltale signs are as follows:

Are you a people pleaser?

Are you always trying to be on your best behavior or presenting a false self that you hope will earn you love?

Are you desperate to have someone you're attracted to pay attention to you, just so you're sure you exist?

Do you heap love and attention on people who might not deserve it?

YES, YES, YES, and YES.

<p style="text-align:center">★ ★ ★</p>

From the time I was a teenager and well into my thirties, I only loved the boys who mistreated me; if any boy was too nice to me, I ran in the other direction.

I just did not get a lady boner for nice people.

I sometimes joke that my love obsession inspired my becoming a professional photographer. I had a lover whom I was in obsession with. We lived in different cities, and I desperately needed an excuse to be with him in NYC, which was where he lived. I'd work my ass off to land a gig in New York just so I could say, "Oh, I'm going to be there shooting." Being in the same place as your love obsession by "coincidence"—textbook love-addict behavior. The only upside to this kind of acting out is that I racked up a shitload of air miles visiting all the cities I coincidentally appeared in.

Love addiction has been severely exacerbated in the digital age. Social media is a major love-obsession enabler, allowing you to hunt your love obsession down detectivelike on various social platforms. One of the tricks of being a good love addict is to enable the "Find My Friends" function on your love obsession's phone, allowing you to track their device and know where they are at all times. You are likely wondering how I know this inside tip.

Well, I will admit to some mortifying behavior. I have on occasion been known to check the occasional text message on his phone or take a peek at his email. When

it comes to digital snooping, if there's one piece of advice I can give, it's this: DON'T DO IT. If you felt bad before, you'll only feel worse after. You will always find something you wish you hadn't, and then you're faced with the problem of confronting him. You can hardly say "I looked at your phone and I saw that text from so-and-so. What the fuck was that all about?" or "Who is Jamie?" Now you're stuck with incriminating information you can neither forget nor disclose. Either you risk exposing yourself as a snooper—and suffer further humiliation—or you keep it to yourself and explode with anxiety or break out in hives, which is what happened to me.

I have done both of the above, and neither is an option I would choose again in a hurry.

Love addiction has led me down some pretty dark paths, to places I would not have believed I could go. You might not think I would be the type to tolerate abuse. I'm a smart woman with choices, a career, and resources—but twice I have loved and lived with violent men, and because of my love addiction, I didn't want to leave either of them. I share this because falling in love with a raging lover can happen to anyone; what's important is how you respond to it. Some of the most beautiful, talented, intelligent, creative, kind, loving women I know have been unable

to overcome their love addiction enough to leave abusive relationships.

I was barely a teenager during my first obsessive and abusive relationship. It was with a dude who drank daily, hit me, and only fucked me from behind with my face in the pillow. Turns out he only dated men after me, but that's another story. One night he waited until I was in bed, naked and asleep, to start a drunken fight about something I've long since forgotten. It ended with him ripping the railings off the staircase and barricading me in the bedroom. My only escape was out the second-floor window. I grabbed my cell phone, a T-shirt, and my underwear and climbed down the drainpipe on the front of the building, where I hid in a trash can for hours, freezing cold, until I could reach a friend to come and bring me to safety.

Guess what?

You would think that this was the last of him.

But I didn't leave.

I went back one more time because he told me he loved me, and I wanted to believe him; if that isn't love addiction, I don't know what is.

Eight years later it happened again. I fell in love with a man who appeared to be nothing like the angry boyfriend from my teen years. Be forewarned—a wolf in sheep's

clothing can be very desirable, especially one who is a famous, ridiculously handsome older man. But despair and depression hounded this particular guy. He would sit and meditate for two hours a day, maybe to try to calm his internal rage. Yet he tried to strangle me when I was in the bath, because he'd gone to the trouble of making dinner and was upset that I didn't come to eat it fast enough. It took me three years to leave that guy. There were police visits, concealer-covered bruises from closed-fist punches to the face, and too many nights spent sleeping on the couches of friends after fleeing his abuse in the early hours of the morning. My shame and embarrassment couldn't have been any greater.

So why would I stay in such detrimental relationships? Why does anyone?

I stayed because I didn't believe I was lovable.

I stayed because I didn't believe I deserved better.

I stayed because I didn't believe that anyone would ever love me again.

Instead, I believed that I'd be alone my whole life if I let go of this guy. It was like Stockholm syndrome, but the love-addict version.

My friends eventually despaired of me. How many times could they implore me to care about myself? How

many times could they reassure me that I was a great person, a loving and generous friend deserving of genuine love, the kind that builds you up, supports you, helps you to be your best self? The truth is that before being able to accept real love, you've got to get some self-love flowing. It doesn't matter how many people claim to adore you, or how fit, successful, smart, talented, funny, kind, or compassionate you are. None of it matters if YOU don't see and cherish your own wonderful self, and back then I certainly didn't.

My friends were a great comfort, but I might have continued mistaking obsession for love had I not decided that I wanted to set a better example for my daughter. I couldn't bear to think that I was modeling a broken and dysfunctional version of love to her. I knew that even if I could not heal for me, I had to heal for her. The first step toward change is to acknowledge the problem.

I was chronically addicted to men.

So I got help . . . I read every book I could find on love addiction. As it turns out, there are a great many. I keep spare copies on hand of my favorite, *Facing Love Addiction*, because I always have at least one girlfriend who is in dire need of it. And most important, I committed to a program that taught me how to not engage with crazy

men and also asked me to look at my part in the insanity in a way I wasn't willing to do before.

Here's the good news: You can recover from love addiction. I am proof of that. The bad news? It is fucking hard. Like other addictions, you're always in recovery. My drug of choice happens to have a dick attached to it, which is part of the challenge. You can't cut romantic relationships entirely out of your life or say you're never going to have sex again, unless you join a convent or take an oath of celibacy. Learning how to have "healthy" attachments sounds easy, but for someone like me, with early insecure-attachment issues, it was like learning to speak a whole new language, and not Spanish but something really complicated, like Cantonese.

One of the harder tasks is being able to recognize which behaviors in a relationship are healthy and which ones cross the line into obsession. Can you still love someone and *not* put him or her at the dead center of your universe? Well, yes, actually, that's the point. YOU should be the center of your universe, and the rest—family, career, significant other, even children—receive your attention, care, and love from that position.

Once I made that adjustment, being alone became less frightening.

Let me assure you, this was not an overnight epiphany. It took years of trying to change and, at times, feeling helpless to do so. True healing takes place slowly and over time. The more I built up my own self-esteem, the more I focused on creating a life I wanted for AMANDA, the more I enjoyed being in my life, and the less I wanted to sacrifice that happiness and balance for anyone or anything.

This freedom has allowed me to be a better and more present mother, friend, and wife. It's given me the confidence to dream up and create a photography career, *The Conversation*, #Girlgaze, and even this book. But, most important, I don't live in that awful, obsessive place anymore.

* * *

Not every relationship is doomed because you struggle with this affliction. I was obsessed with, and I will begrudgingly admit to being addicted to, my husband Nick during our first years together. But I was aware of it; I worked on it, as though my life depended on it, and we've now been together for sixteen years and married for eleven.

Our relationship has been one long process of healing. It's taken years for both of our trust issues to calm

down. Nick is an intensely private guy and will not be happy with me sharing anything personal about him, so I'll keep this part brief. All I'll say is that he's as good a lover as he is a guitar player, he's an incredible dad, and he gives me the kind of unconditional love that I now know I deserve. Well, most of the time, that is . . .

4.

I Know Myself Better Than You Do: Some Thoughts on Sex

Disclaimer: *Atlanta de Cadenet Taylor, my firstborn daughter, do not read this chapter as it will creep you out. TMI about my sex life.*

Contemporary culture focuses so much on the need to have a great sex life. They say sex sells, and it certainly is used to sell everything from hamburgers and cars to vacations and even electronics. Yet when it comes

to the way media represents sex—from TV to Oscar-winning films to porn—the pleasure of women is presented as secondary, if presented at all.

It's no great surprise that when it comes to depicting sex, the male fantasy prevails. After all, the majority of the top jobs in media are held by men, so they control the narrative. The standard sex scene features a guy thrusting in and out a few times, after which his female partner has a loud, satisfied orgasm. The subtext is always that women are there to service men, to offer pleasure like a fast-food restaurant—open around the clock with no questions asked, just like McDonald's.

It's not entirely the fault of the male-driven media, as all media is doing is reflecting back the truths of our culture at any given time. And in our culture, women often aren't taught anything about their own sexual pleasure.

In my opinion, long before we have sex with someone else, we need to be comfortable having sex with ourselves. Eva Longoria said it best when I interviewed her on *The Conversation*: "I didn't begin enjoying sex until I started masturbating. It's a shame I didn't discover it sooner." And yet, so few of us do. According to the *Journal of Sexual Medicine*, only 33 percent of girls fourteen to seventeen

report masturbating regularly, and less than half say they've even tried it.

Granted, we should factor shame into those self-reported numbers. One of the earliest messages we get as females is never, ever talk about our genitals or our sexuality, especially when it comes to masturbation. Boys have a million words for the act and talk about it endlessly, almost competitively. Many of the most popular terms sound aggressive and violent, like jerking off, spanking the monkey, choking your chicken, or rubbing one out. What do we have? There are far fewer descriptive words for female masturbation, and they're pretty lame and inaccurate. Paddling the pink canoe? Flicking the bean? Who would want to flick the bean? That's NOT something I want to do to my vagina.

My ten-year-old daughter Ella came home from school one day with a book on human development. It describes female and male anatomy and genitalia technically. A vulva has the labia, which protects the vagina from infection. The urethra is where urine comes out. But when it came to the clitoris, the book didn't say, "This is the part that makes you want to do it. This is the bit that makes sex feel good for a girl." It didn't even attempt to address this prime lady

pleasure center with a bit of biological talk, at the very least referencing nerve endings. It didn't list a function for the clitoris at all. Just left it blank. And nowhere in that book did it say that sex, aside from procreation, feels great.

How can we figure out how to satisfy ourselves when our anatomical pleasure center is excluded from most sex education books? The clitoris is such an incredible little, or sometimes large, knob, a powerful force in a neat package, and named so perfectly.

But I guess this exclusion is not surprising considering that the vagina, or the V-word, for those too afraid to utter its proper name, tends to make people nervous. Strangely, people seem more at ease when using the word as part of an insult, like accusing a woman of voting with her vagina or calling someone a cunt. I do my best to integrate the word vagina into our home vernacular, to normalize it, if you will.

I told my daughter, "You know, your vagina is just another body part, like your eye, your nose, or your elbow."

"Then why are people so embarrassed about it?" she asked. "If it was the same as an elbow, people wouldn't be embarrassed and it wouldn't need to be covered up all the time."

Not getting ANYTHING by this ten-year-old girl.

IT'S MESSY

I'm passionate about girls empowering girls and that
includes understanding their sexuality and feeling con-
fident about it, likely because my own early sexual experi-
ences were confusing, disappointing, and also filled with
a lot of slut shaming. When I was in boarding school in
England, I don't think they even had sex ed. If they did,
I missed it, as I was too busy making out with local farm
boys. My only experiences of sex ed as a girl were look-
ing through a book on Greek mythology that my parents
kept in the living room, which contained photos of stone
statues having sex. Not very useful, but it did make my
vagina beep. And I read a copy of *The Joy of Sex* handed
to me by a pervy neighbor when I was nine, which I knew
instinctively to hide under my mattress.

As it is with many girls, my sex ed was trial and mostly
error. I didn't even kiss anybody until I was fourteen. One
summer afternoon my mom took me to her country club,
the most upper-class, white place you can imagine. I was
extremely awkward and very nervous, hanging out with
a bunch of other country club kids. I kept thinking, *I just
don't fit here. These are not my people, but goddamn it, I
am ready to make out with someone.*

The boys made a game of stealing their parents' glasses of champagne when the adults weren't looking, then getting drunk and hooking up with the girls. Even though I didn't feel as if anyone would like me, I was hoping that this particular summer, I would be chosen. I did not know that I could participate, that I had a choice, that I could initiate. I was just a flower waiting to be picked.

I eventually wound up under a rosebush with a boy called Rob. I don't know if he was really called Rob, but he looked like Rob Lowe, and that has always been my name for him. So Rob and I were under that shrub for what seemed like two hours, making polite conversation while I was just waiting for this cute kid to kiss me. I remember wondering if it always took this long to get kissed. In the end, with his champagne breath in my face, we did have a very wet, saliva-filled kiss, which I have to say was horribly anticlimactic. I have no idea how long we were lying in the dirt, but eventually I climbed out from under the bush with weeds in my hair and scratches from the rosebush on my arms and legs and made my way back to find my mother. I was practically walking on air—I would finally have a kissing story to share once I went back to school.

Next there was a boy I'll call Tom. I made out with him

in my mom's bedroom while she was out playing tennis at the country club. My most significant memory is of him unbuckling his pants, pulling down his underwear, and forcing my head down, onto his dick. Then he did what all teen boys do: he came in seconds. It happened so fast I gagged. And my mouth was filled with the disgusting taste of what I can only describe as pureed onion. My sexual experiences were going from bad to worse. I've no doubt suffered some PTSD from Tom's maneuver, although back then forced fellatio was written off as regular teenage boy behavior. But actually, it was closer to nonconsensual sex, and I was traumatized. After Tom, it took me another ten years to be able to give a blow job, much to the frustration of the boys I was with.

I lost my virginity to my first boyfriend, who I'll call Augustine. He was in the school band, but of course, and was a sweet guy who sent me funny letters when I was away from him at boarding school.

I was fifteen and considered a late bloomer compared to my friends, who all bragged that they had had sex. I set aside the disappointment I'd experienced over my first kiss, and the horror over my first blow job, and consciously decided that it was my time to do IT.

I took the subway from Fulham Broadway, where I lived,

to the end of the subway line where he lived. I walked the fifteen minutes from the subway stop to his house, filled with purpose. I was a girl on a mission to lose my virginity.

I got to his house to find his buddy was also there, lounging on the very sofa I had planned to lose my virginity on. Why is it that some dudes always have a wingman who needs ditching?

But I was not going to let anything get in the way of my plan today. I think I made some lame excuse about being tired and wanting to lay down, so Augustine and I went upstairs to his bedroom. We lay on his bed, me nervously staring at the bright sunlight that was hitting my face and making it hard for me to keep my eyes open. Was I even supposed to keep my eyes open? Or closed? Or to look at him? Or not? Jeez, who knows what to do when you haven't done it before. He awkwardly tried to take off my clothes, but we gave up after the debacle of getting my jeans and knickers off, and I took the rest off myself.

I will at least give him a gold star for proper consent etiquette, as he did ask me if I was sure I wanted to do it. I could barely squeak out the words, "Yes, I think so." I also nodded, which was his invitation . . . to roll on his condom, climb on top of me, squeeze his penis inside my

virgin vagina, and come in about twenty seconds. He then pulled out, rolled the condom off, and hopped off the bed, leaving me in the same position I was in thirty seconds earlier. Still blinded by the sun, except minus my knickers and, most important, my virginity.

No blood, no orgasm, just confusion. And another disappointment.

As I walked back to the subway station a short while after, with an uncomfortably agitated vagina and damp underwear, the overwhelming thought was why I would ever want to do that again. (Sorry, Augustine.)

I should've known then that sex was not going to be anything to get excited about until much, much later. In all fairness I have never heard of a girl having an orgasm during her first time. If that is you, then I want to hear from you, please!

In my early twenties, after being married, having my first child, and then getting divorced, I discovered the joy of the one-night stand. There are times when having sex with someone for only one night is NOT a bad thing. Some of my favorite sexual experiences have come from one-offs—people I never wanted to see again but whom I'm incredibly pleased I spent the day or night with. Of

course, I try to avoid making decisions I'll regret the following morning, like not having safe sex. What I'll also say is that, having been married to the same dude for eleven years, I think the benefits of sex in a long-term relationship far outweigh the one-night deal.

However, the sex I had in an NYC hotel room with a semi-anonymous guy was among my top ten sexual experiences. He'd somehow got my email address and had been sending me incredibly sophisticated pornographic poetry. I didn't know anything about him other than the guy could really write.

Via email, I arranged to meet him in New York, at the Gramercy Park Hotel, with the instructions: "I will leave a key for you. Just say you're my boyfriend."

I woke up at three in the morning with this guy going down on me. We fucked, and I didn't even look at him until we were done, which wasn't until the sun came up.

"What are you doing later?" he asked me, postcoital.

I told him I was busy.

"Do you want my number?"

Did I ask for it?

I never expected to see this guy again, but I did run into him one time, ten years later, walking up the beach in Malibu, married to a girl I knew.

If you are inclined to choose the option of one-night stands, then there are ways to do it that have worked well for me.

I have three rules:

1. **Stay away from other people's partners.** There are enough people in the world. I feel really strongly about that. If someone says, "It's fine! My partner doesn't mind!"—get that partner on the phone because you'll find out what's up right away.

2. **Be safe.** You don't want to leave with more than you arrived with. Unfortunately, there are no birth control options designed specifically with women in mind, so I know the choices don't seem too appealing. If men could get pregnant, then I am certain we would have some better alternatives. However, given that, I always go with the "just DO it" motto, meaning "rubber up"—because taking a risk for a night of fun was just never worth it for me.

3. **Be age appropriate.** When I was thirteen, I looked much older, so I had men in their thirties try to sleep with me, and just because I had B-cup boobs,

it was somehow acceptable. A fourteen- or fifteen-year-old girl is not emotionally equipped to manage a guy in his thirties. These men were interested in me for sex and sex only. Let's not be confused here. These guys are total creeps.

I think I learned how to flip the script with men as a way to combat and avoid being mistreated, as I so often was. One of my first LA girlfriends, Stacey, was ten years older than me and taught me a lot about men, including how to give a great blow job, which she literally demonstrated on a cucumber for me to watch and take notes.

Stacey lived with her pit bull in a Winnebago she bought with money made from stripping across America, and she was as badass of a woman as I'd ever seen. She was gorgeous, sexy, and blonde, but God help you if you fucked with Stacey. I've seen her get a Glock out of the glove box at a red light and aim it out the window at some dude who had catcalled her.

I met her when I first moved to LA, and we bonded over riding motorbikes . . . and boys. She is one of the most loyal, loving, incredible women I know. So much so that one year on my birthday, she gave me the most insane gift that only she could give me.

"Go to this address after one a.m., and don't ask me any questions," she instructed.

I trusted her with my life, so I went to the address and rang the buzzer. A guy I recognized as a super foxy guy she had been having a fling with answered the door.

"Hi, you're Amanda? Stacey told me you'd be coming. Come on in. I'm your birthday present."

WEIRD. I wanted to leave, but I also wanted to stay.

"How do I . . . what do I do?"

"Come in."

Alrighty then. I don't even remember much of it; I must have been drinking still, but I remember just having the craziest sex in a room that had mirrors everywhere. It was truly a surreal but excellent experience.

Afterwards, all he said was, "Well, happy birthday."

"Thanks, dude," I said, and put my clothes on and left.

It's hard to define the difference between sexual empowerment and tricking yourself into thinking it's empowerment when actually you're just finding a way to get validated. There's a whole sex positive movement right now where people are staying out of any kind of committed, monogamous setup and having sex with whomever, whenever. Which I fully understand. At the same time, it's really hard to know what that line is between feeling liberated

and starting to feel bad about yourself or shamed in any way. If you start to feel empty and used, that's probably a sign that something isn't working for you.

We're raised to believe love and sex should be connected, but most of the time that is not the case. The truth is that most people are having sex not because they are in love; most people are having sex because it feels good. And there's nothing wrong with that. Sex is about the most personal choice we can make, and it should be ours to make freely. Whether it's random sex or committed-relationship sex or even celibacy, as far as I'm concerned there's no right or wrong—it's whatever works for you that doesn't mess with other people.

<p align="center">★ ★ ★</p>

When I was a contributing editor at *Marie Claire*, I collaborated with the magazine on a comprehensive survey of more than a thousand women in what was called "The Porn Project." Here's what the surprising results showed: Only 12 percent of the women surveyed said they watched porn with their partner, and only 17 percent said they watched porn because it helps them understand what their partner likes. However, a whopping 61 percent of

the women surveyed said they watched it regularly (every week or a few times a month)—alone.

I was surprised and thrilled.

Using porn to cultivate one's own sexual agency is a different story from the common wisdom that women feel threatened by it or watch it reluctantly in order to please their partner. Instead, the study showed that women are using porn to learn more about what they want and to figure out how to please themselves. What does this tell us?

Several things. First, a myth still exists that women aren't as sexual as men. In a related survey, 60.8 percent of women polled desired sex three to five times a week. This flies in the face of the theory based on Darwinism, which contends that only men desire a lot of sex and therefore need to spread their seed far and wide. Nowhere does it say that women just want to fuck one guy and have him protect her, her baby, and her home for the rest of her life. This interpretation is patriarchy at its finest, and in my opinion Darwin's theory needs an update.

Second, and more important, women's sexuality is complex and multifaceted, and is not given the attention or priority it deserves.

From our first sexual experience onward, women tend

to define good sex by how pleasurable it was for their partner, not how it was for them. This is in a heterosexual relationship—lesbians seem to focus more equally on each other's pleasure, judging from an unscientific polling of my friends. On a positive note, at the beginning a girl doesn't need any real skills whatsoever. If you're with a fifteen-year-old boy, it's likely going to be over while you're still fully clothed.

But sex is reciprocal. It's not about girls serving boys. Our experience is as important, if not more important, than the person's we're doing it with, and we have to be responsible for that experience. If we don't know what feels good, if we don't know what turns us on, if we don't know what works for us, if we don't know our bodies, we can't expect anyone else to.

Unfortunately females are generally unprepared for their early sexual experiences. Orgasms—and periods for that matter—are bodily functions that all genders should be familiar with. I recently explained to my son what a period is: the biological benchmark that signifies a girl can be sexually active and have a baby. Yet in Western culture there is still a level of discomfort and embarrassment when a girl gets her period, as opposed to it being

honored as a significant marker of transition from girl-hood to womanhood.

And can we just talk about orgasms for a minute.

The first time I had an orgasm felt like an out-of-body experience. I knew nothing about orgasms and didn't know what was happening to me. I was fifteen, and a boy I was fooling around with was going down on me whilst I lay on his shitty threadbare carpet. Suddenly, a wave of sensation, like pins and needles but different, rolled from my pussy up my torso and down my limbs. I felt as if I would black out, or as if I were leaving my body. The wave passed, and I thought, *Whoa! What the hell just happened to me?*

At the time I did not know that I had just experienced my first orgasm.

How then do we educate ourselves and our daughters about the power and wonder of our sexuality? First, we should look into something called the Dutch model. The Dutch start "sexuality education," not "sex education," in kindergarten, and it's about so much more than anatomy and physiology, or even the act of intercourse. It allows for "honest, open conversations about love, relationships, and personal boundaries," the program's advocates say.

As it progresses, children get frank information about "self-image, developing your own identity, gender roles, learning to express yourself, your wishes and your boundaries."

Parents don't need to wait for their kids' schools to join the modern age. We can start talking about sexuality early and often. To avoid the topic for too long leads our kids to the inevitable secret online search for some clue as to how it all works. This may seem shocking, but the average age of googling free porn is nine. To fail to talk about sex is also to fail to talk about porn, which is pretty much the same thing as dropping your kids off in a war zone in the middle of the night and saying, "Good luck! Hope you make it home!"

I've already explained to my kids that porn is a genre of movie. Not a documentary, which tells the truth, but a fictional movie. There are horror movies, science fiction movies, comedy movies, and sex movies, all of which are make-believe. Anything you see in those films is not real. I've also said there are some people who think it's a good idea to make films of people having sex, and many people like to see those kinds of things. There will come a time where you may have a friend who says, "I want to show you this," or you may see something like this on-

line. I want you to know that porn exists. I also want you to know that this is not how sex is. This is a movie version, so do not expect or think that this is what men look like, women look like, or sex looks like. Oftentimes porn is mean to women. And some porn will even seem like a horror movie.

Some parents may feel that this is TMI for ten-year-old kids, but trust me when I say, if you don't have this talk, the internet will do it for you.

<div align="center">★ ★ ★</div>

Having an active, fulfilling sex life is more complicated today than ever before. The advent of the digital age has hugely changed the playing field. What used to be written in private diaries (my own excluded) is now captured on camera and shared via social media, creating a record of sex acts that can never be erased. We all know this, yet the compulsion to share all aspects of our lives has overridden common sense.

Remember the infamous "Hollywood hack" where a number of famous actresses had their intimate nude photos released on the internet? Aside from the obvious privacy breach, what struck me most was that none of the high-profile names were those of famous men. Among the

leaked images of lady body parts and sexcapades, there was not a single dick pic. Not surprising, as no women stole and leaked the images.

At what point did it become normal for us to assume that if a woman takes private pictures of herself, she should expect them to eventually be circulated online for countless men to jerk off over?

So what to do then? Should we all stop being playful for fear of being humiliated down the road?

Photographic expression of your own sexuality can be a beautiful thing, but only if it is consensual. Leaked nudies, and the resulting stigma, are the most public version of slut shaming there is. This horrendous invasion of privacy delivers a disturbing message that women cannot be openly, joyously sexual without severe consequences.

It took me years to recover from having my diary published and my private life publicized in ways that I'd never expected and that left me traumatized. I have nothing but empathy and compassion for anyone who has experienced this violation.

The slut shaming I encountered in my teens continues to this day. In 2016, when I interviewed Hillary Clinton on *The Conversation*, a UK tabloid ran a story about my

sexually provocative teen years, as if to prove that, even though my work has earned me the opportunity to interview America's first female presidential candidate to be nominated by a major political party, we mustn't forget that Amanda is really a slut because she had sex when she was fifteen.

Really?

I refused to allow myself to be taken down by some tabloid printing untrue stories about my dancing on a table without underwear in a pub half a lifetime ago. I'm optimistic that the more women gain positions of power, particularly in media—whether it's in journalism, publishing, TV, movies, or digital platforms—the less our sex lives will be used to define us.

★ ★ ★

Female sexuality evolves over time, from puberty on through menopause. One of the biggest adjustments occurs after you have kids, when you might not even recognize your own libido. I often get asked, "Do babies really fuck up your sex life?"

Sorry to say this, but much of the time they do. I'm pretty sure it's a combination of a natural drop in desire—

our body's way of protecting us from getting pregnant again before we're ready—and the reality that a new mom is tired as fuck. Or should I say too tired to fuck.

New moms ask me all the time, "When did you feel like having sex again?" There's no concrete answer—we are all so different. I could say, "In three months on the dot, you're going to remember you have a vagina again." But honestly, until your baby is at least a year old, don't let anyone tell you that you "should" be having sex on a regular basis. Anyone who tries can probably be described as follows:

1. **Has a penis**

2. **Has never had a kid**

3. **Does not really like you**

The simple truth is that our partners should not expect much action for quite a while postpartum. This reality is unlikely to be accepted with a smile, but it's a conversation that mothers need to be comfortable having.

There are many stories about men cheating when their wives are pregnant, or just after the baby is born, because

they're not getting laid. It's a lame excuse. Sorry that you're not getting sex as often as you want, New Dad. I'm breastfeeding a baby all night with swollen tits; I'm sleep deprived and probably experiencing some postpartum depression as well.

All this aside, the bottom line is that in my home a happy man is a man who is getting laid regularly. So despite everything I've written about owning and respecting your own sexuality—and as disempowering as it may sound—to sustain any sort of long-term partnership or marriage that involves a dude, sometimes it makes everyone's life easier to just do it.

I am aware that this sounds extremely contradictory to many of the things I am telling you, but I have to tell you the truth, and this is just the reality, at least it is in my house.

For the extremely busy or tired lady, relationship experts recommend scheduling sexy time. That's not a bad solution, even though there's nothing less sexy than scheduling sex. Sexuality thrives on unpredictability and spontaneity. And unfortunately, raising kids requires the opposite—routine, consistency, and reliability. It's a perfect conundrum. Going away for the weekend and getting out of your routine can also reenergize your sex life . . .

when it doesn't create even more pressure to have sex, which it often does.

There is the time issue. There is the lack of sleep issue. There is the new person or people in the house issue. For the first year after our twins were born, I always had at least one baby in the bed and one baby attached to my boob. For the record, that did not stop my husband from trying to have sex with me, giving new meaning to the word *multitasking*.

There is also the way we feel about our bodies, which is always a big component of sexuality. Many new moms feel shitty about themselves. In addition to the emotional side of giving birth and being a mom, your body is going through huge changes. And heads up, there might be some permanent physical changes in areas that you didn't expect.

Yes, even your vagina can change shape during and after pregnancy. I had twins vaginally, and no question, my vagina has never been the same. I gave my husband, Nick, the option between a C-section and a vaginal birth: "Do you want a floppy stomach or a floppy vagina? Pick one." He opted for the floppy vagina, so whenever he mock-complains, I say, "Dude, you chose this."

The American Society for Aesthetic Plastic Surgery

reports that requests for labiaplasty, which reduces the size of the labia minora (and costs around $7,500), increased 15 percent in 2015 alone. In 87 percent of the cases, according to the International Society for Sexual Medicine, women underwent the procedure for "cosmetic purposes." One stat I came across claimed that in Los Angeles alone, two thousand women per day are getting so-called saddle surgery in order to have a so-called designer vagina.

In my experience it's rare that women don't like the look of their own vaginas, but I've heard plenty of women say their husbands and lovers have complained. Which is heartbreaking.

Nick loves my body at every shape and size. Whether I'm 210 pounds—my weight before I gave birth—or 160 pounds, he is happy. Never has he told me I was overweight, or commented on what breastfeeding has done to my boobs, or judged the silvery stretch marks on my ass. That's the kind of man I married. And even if I could have a hall pass, I'd still take my hubby over anyone in the world.

Except maybe Louis CK (weird, I know) . . .

Porn Culture, and Its Effect on My Vagina

If you're like me, you probably know the details of your girlfriends' below-the-belt grooming habits, whether playboy or playkini, Brazilian or landing strip or seventies bush. But the trend I've noticed on my outings to the all-female, all-naked Korean spa I frequent?

Bald. No hair. Totally gone.

I don't know if you've ever taken off the whole lot. I did it once, just for the hell of it. It was fucking brutal. (Never get a wax when you are about to get your period—it's that much more excruciating.) I screamed and cursed

so loudly the beautician asked me to be quiet or she'd leave me with a half-waxed vagina. After my shearing was complete, I reached down to touch my newly hairless vagina and felt remnants of sticky wax on my labia. In fact, as I awkwardly felt around, I realized that my labia were stuck together.

"Excuse me, miss," I said, "um, my labia are sealed shut. There seems to be some wax you left down there. How do I get this off?"

"Oh, don't worry. Let me put some oil on you and that wax will come right off," she said, reaching for the baby oil.

"Actually, I'm not entirely comfortable with you rubbing my genitalia. Give me the oil and I'll do it. Myself." I think I was partly horrified, and partly worried it would feel inappropriately good. I also debated whether to tell my husband about this (like the time the foxy masseur started rubbing my boobs with massage oil whilst I was asleep on the massage table).

I'm not sure which option offered less dignity—having her oil me up or lying on the table and doing it myself while she cleaned up the wax strips now covered with the hairs that, for so many years, had covered my mons. I don't mind having someone inspect every inch of my

vagina at a gynecological exam, but to go through that for vaginal vanity? Not so much.

Removing all my pubic hair revealed some big surprises. The first one being that I have stretch marks. Big silver lines, snaking their way from one side of my pubis to the other. They look like a dry riverbed seen from space, winding across a once fertile land.

I carried three people inside me for fuck's sake, I think, defending my stretch marks to myself. *Who wouldn't have these?!*

Wait a minute, don't tell me I'm affected by the Perfect Pussy Syndrome (PPS)?! I remember being horrified by a story I once heard about a young woman whose delightful boyfriend had told her she had "beef curtains" because her labia hung down. What kind of asshole says that to his partner? Perhaps someone who wants a trophy and not a person.

And now, here I am looking at my naked, imperfect pussy. I immediately remind myself that my brain does not control me but that I control my brain. I can tell it whatever I want it to latch on to. I start to go down my "Amanda Is All Right" go-to list that I recite when I feel some self-shaming coming on.

1. I am kind.

2. I care about other people.

3. I am a mindful mother.

4. I have a healthy body.

5. I am a loyal friend.

6. I am honest.

7. I have a perfect vagina just the way it is.

Then I climb off the waxing table, which is when the second surprise reveals itself. I look down, and there it is, undeniably visible: Hanging above my newly naked vagina is a lip of saggy flesh that my friend Amber V. calls a FUPA. Yes, I have a fat upper pussy area. I do. It was hiding under my seventies bush all that time. Who knew?

Now I get why some women schedule cesareans with a tummy tuck on the side. I could never understand why a perfectly healthy woman would opt for a surgical birth. Until now.

If I hadn't opted for that natural twin birth, I would not have this offending piece of flaccid flesh hanging off my body. So much for that great choice, Amanda. Now look what you've done to yourself.

Oh, there it is again, that negative, demeaning voice telling me a bullshit story—one that I know isn't true but seems true for as long as I let it run. I reel my mind back in again.

My body has held three full-term, healthy, strong, fully formed babies. People I love. With all my heart. Be thankful, Amanda, not resentful.

Fuck you, negative thinking. I don't care if I have a FUPA, or if I have stretch marks, or if my tits are pointing in different directions and I have nipples the size of a dollar coin. I thank you, beautiful body, for giving me those gorgeous babies who make my life worth living.

I repeat this under my breath, like a mantra, as I pull on my size 14 knickers over my ample ass and newly befriended FUPA. I leave the beautician a big tip. After all, removing the entirety of a seventies bush was a big job, even if she did stick my labia together with her Egyptian, hypoallergenic, organic, rash-free honey wax.

Why do so many women choose to go bald, to go through this ordeal regularly? Why do so many men

encourage us to? In my humble opinion, it's simple: Porn culture has woven itself into the very fabric of our bed-sheets.

Boys and girls as young as nine years old are googling the terms *porn* and *for free*; in fact, free internet porn is often their first exposure to sex—it's serving as most kids' sex ed these days. It's no longer parents, siblings, friends, schools (or books of Greek mythology) that are teaching kids about sex, but the distorted lens of pornography. Porn culture is influencing our most private life experiences in an unprecedented way.

Imagine if your first exposure to a vagina was one that was devoid of hair, available and open like a twenty-four-hour fast-food eatery for you to enter whenever you want, capable of an orgasm within seconds, and squirting like a water fountain? You'd probably have some very high expectations when you got your hands on a real one. I know I certainly would.

If the only dicks I'd ever seen were unusually huge, capable of staying hard for hours, and situated next to shaved nut sacks and hairless buttholes, I'd feel really confused when I got one that wasn't all those things.

Thanks, porn culture; you've done a great job of am-

plifying the existing awkwardness of early sexual encounters.

Personally, I'm a little alarmed by grown men who want their women bald as an eight-year-old. Don't you wonder where that preference is coming from? I do. My husband tells me it's just more "practical" and "easier to get to all the hidden bits." Fewer pubes stuck in the teeth or down the back of the throat. Okay . . . but what about the fact that only little girls have hairless vaginas? I just can't help but think about that as I wait for my car outside Super Wax.

It's sunny outside. It's always sunny in Los Angeles. I reach for my shades as I get into my car and drive down Ventura Boulevard, which is lined with billboards advertising strip clubs, escorts, places to meet a sexy local— all showing me ladies with barely any clothes on and the promise of a good time and, I'm sure, hairless vaginas.

I've joined the club, I think as I drive home. *I've got the bald eagle!* Except I wish it weren't so sore. I'm sweating now, and the sensitive just-waxed skin on my vagina is stinging like mad. Maybe this wasn't a good idea. I just want to scratch it. What if someone sees me furiously scratching my vagina in my car? Not a good look.

I spend the next few weeks trying not to itch myself incessantly at inopportune moments as the regrowth emerges. As my pubes come back to life and my vagina starts to look like that of a grown woman and not a plucked chicken with a bad rash, I tell myself, "Remember this the next time you feel like your vagina needs to meet the social norm. It is YOUR vagina and you should do with it as you please. No matter what anyone else says."

If having a bald vagina makes you happy, then I say go for it—but make sure you are doing it for YOU, not because porn culture or anyone else tells you to.

6.

The Love of My Life
(and There Are a Few)

I don't believe in the notion that you have only one love of your life.

Life is constantly in motion and hopefully we are always changing with it.

A person you deeply connect with at one point in time is not necessarily the person you want to be with forever. The idea that there is only one person for you, or that you should limit yourself to one ultimate love, is a belief system that keeps us desperately searching for our idea of the perfect partner, sometimes for way too many years.

How about the concept that there is a love for every

stage of life, whether that is the same person or someone new?

* * *

I was a twenty-year-old wife and mother when John and I moved to LA. It was a relief to be free from living in the fishbowl that my life in London had become. Being the object of ongoing press attention, which included endless body shaming that began when I was pregnant with my first child, was no way for anyone to live. The tipping point came one day after some paparazzi made it their mission to capture a picture of my lactating boobs while I was breastfeeding baby Atlanta on a bench near my house in London.

That was it. I was done.

Within days I had packed a couple of suitcases and left for California, leaving food in the fridge and laundry in the hamper, and didn't return for over ten years.

Moving to LA was such a relief, but it had its own challenges. I lived a much simpler, anonymous life of a new mom caring for her baby and breastfeeding without being harassed, but soon after we moved, my then-husband went on tour with his band, and I found myself alone with a new baby in a new city where I knew only three people.

One of them was a young man I had interviewed two years earlier for my talk show *The Word*. He was insanely handsome, charming, and he made me laugh like crazy. I couldn't pronounce his name for the first few months after we became friends.

"I'm sorry to ask again, but HOW exactly do I say your name, KEE-AHH-NU?"

(Dear Keanu: I tried to leave your identity out of this, but given the gigantic impact you've had on my life, I had to call you by your name and not some weird pseudonym.)

Keanu Reeves is my love-at-first-sight story, or at least, my first love-at-first-sight story. We met when I was two months pregnant, nineteen years old, and married to another man. On the day of our interview for *The Word*, we met at my house in London; he arrived on time, as usual, and I was running late, as usual.

Within minutes of first laying eyes on him, I remember thinking, *I wonder how many pregnant women have affairs?* I was surprised by my strong attraction to a man I had just met. As I would soon learn, Keanu is a man with hard-core ethics when it comes to doing the right thing, which is one of the qualities I greatly admire about him. From the day I got divorced, two years after we first met, I tried every goddamn trick in the book to get him

to submit to my advances. Even my tried-and-tested seduction tactics, which had otherwise worked with 100 percent success, failed with Mr. Reeves for many years. He was having none of it, and thank God because had we become lovers at that point, I don't think we would have the powerful and transformative friendship that we have today.

Somehow, Keanu knew that what I needed more than anything was platonic male love, and that was what he gave me in spades until it became clear that maybe being lovers wasn't such a bad thing after all.

As I write this book, Keanu and I are twenty-six years deep. In that time he has been my best friend, my brother, my father, my lover. He is unquestionably a soul mate, whose unconditional love has helped me heal many deep wounds. But most of all, he has been and continues to be my champion in all things and in every way.

I do believe there is a lover for every stage of life, and Jimmy in the trailer is the perfect example of that. Jimmy lived in a dilapidated trailer in Topanga Canyon. He was a smart and brilliant man, but always shirtless and shoeless, the quintessential starving artist—with the mind of Nietzsche and the body of Tarzan. We had crazy great sex

and stayed up all night eating whatever he cooked up on his plug-in stove top.

I was so into Jimmy in the trailer, but at the same time knew this would never be anything more than a really great vacation for my neglected vagina and battered ego. I met him after having been in an emotionally and physically abusive relationship for almost three years with a dude in London who had been my childhood obsession. Let's just say that guy turned out to be a wolf in a practicing Buddhist's robe.

My time with Jimmy was healing on many fronts, and I'm grateful for it. He taught me that there was most certainly a time and place for a relationship like the one we had. Most days it looked something like this: drop off my daughter at school, drive to Topanga, and spend the day having great sex, napping, and walking to the beach through the Topanga woods. It was exactly what I needed at the time, and in fact, I think every girl needs a Jimmy experience at some point in her life.

Then I dated a guy who lived in the back of a U-Haul truck and had a vicious drug problem, but his insane cuteness and charm helped me forgive his living situation. He had no money and no wheels (aside from the U-Haul),

and used to walk for two hours to come visit me. He took me on my first official American road trip to San Francisco, where we got tattoos together, little matching stars on our hands. I also got my daughter's name tattooed on my upper arm, and he got his own name tattooed across his chest. That should've been my first sign that he could be a classic narcissist, but as usual I stayed in the relationship until the message was beyond loud and clear. For my birthday he gave me a tiny green poisonous frog and also gave the same kind of poisonous frog to his other girlfriend, whose birthday happened to be the same day as mine. I can't remember how his other girlfriend and I found out about each other, but we both got rid of him immediately, and she and I are still friends today.

It was around this time that my shrink said to me, "You know, you're not Madonna."

What did she mean I'm not Madonna?

"Madonna is rich enough to fuck whomever she wants, but you're not her. Get a guy with a job."

That really stuck with me. Did she mean that if a woman has enough money, she also has independence and her romantic options increase? That she can actually *afford* to fuck whomever she wants? That she doesn't have to compromise her lifestyle or the quality of her day-to-day life

just because she's fallen for a guy who lives in a trailer? That's exactly what she meant. I heard it, and that was the end of U-Haul Man, who, for the record, wound up landing the lead in one of the most successful TV shows on the planet. The U-Haul is long gone, I'm sure, and he's now super well paid and is making some lady—or knowing him, multiple ladies—very happy.

<p align="center">★　　★　　★</p>

As a single woman after my divorce, I learned a valuable lesson about the guys I hooked up with, whether for a few weeks, a few months, or in the case of Keanu, many years. It's this: *Listen to what he's telling you about himself; he's letting you know who he is.*

If a guy says, "I don't want a girlfriend," he means it. Sure, you can use your charms to seduce him into thinking otherwise, but if you're trying to turn a sexual attraction into something more, you're wasting precious energy. I've been in this position a few times, and I always ended up feeling that the guy wasn't there of his own volition—which he wasn't. I had simply succeeded at manipulating him, with sex most likely, to stay a little while longer. Save yourself the headache and the heartache. When he says "I'm not a relationship guy" or "I've never been faithful" or "I

drink waaaaay too much," take him at his word and run in the other direction as fast as you can.

People do not change because you want them to; they only change when they want to. I can't count the times I've fallen in love with someone's potential, created a fantasy, and then been endlessly disappointed that he's not the person I projected on to him.

<p align="center">★ ★ ★</p>

Speaking of fantasy men, I met Nick Valensi, the man who would become my second husband, in 2001. He was just twenty-one, and his band the Strokes were releasing their first album, *Is This It*.

My friend Jacqui invited me to watch the band during a live appearance on MTV. And as fate would have it, I arrived at the studio and wandered into a room where I hoped to find Jacqui. Instead, there was Nick sitting on a chair, bent over his guitar. All I could see was the top of his head and his mop of wild curls. He looked up at me with his wide blue eyes, and I had one of those profoundly knowing moments. With every ounce of my being, I knew. *If you don't turn around right now and get your ass out of here, you are in for the long haul with this one.* But I couldn't get my feet to move and instead found

myself inviting this stranger out for dinner that night and the next night and the one after that.

There is no bigger nightmare than getting involved with a musician who's about to hit it big. I did not want to live through this boy's rite of passage into rock stardom, which I was certain lay imminently ahead. But my heart had other plans for me.

Being with Nick felt freeing in a way I hadn't experienced before. I spent time with him at his apartment in New York, staying up late as I had no 7:00 a.m. car pool to get up for. I felt free from responsibility for the first time in so many years, and boy, did it feel good.

Our early relationship days and nights were so much fun. And as I predicted, what started as somewhat of a rebound from my previous relationship and my grown-up life began to turn into something more serious.

There were moments I tried to discourage our relationship. "You're about to get super famous," I'd tell him. "You should go have sex with as many supermodels as you can, and when you're not as successful, then get back to me. I am not going to commit to a twenty-one-year-old beginner rock star." To which he would say, "I will never meet another woman like you, and I just want to be with you."

He was of course right and somehow smart enough to know it.

The beginning of our relationship was not without issue. We were coming from very different worlds and at completely different stages of life, but through tenacity, hard work, and a touch of codependency, we persisted through more than our fair share of hard times.

I'm not really down with the old-school notion of marriage, where "two people become one." I've never understood the concept of two half people coming together to make a whole person. If you're in love with a half person, get out fast. Likewise, if you think you're only half of a person, you should probably figure your shit out before you get married. Don't expect your union to be the answer.

Also, the "romantic" idea that you must deconstruct your own boundaries in order to merge with someone else is codependency at its most extreme. When you've worked as long as I have to form your own identity, the last thing you want to do is blur the line of where you end and someone else begins.

Both times I've been married I've kept my own name. I like it. It's me, and I see no reason to abandon it. Of course, all-consuming romantic love as a requirement for

marriage is a modern phenomenon. The idea of marriage is older than recorded history, but it wasn't originally just about love. Arranged unions were a way for families to create useful alliances and solidify bonds with other tribes and families. The happiness of the betrothed, particularly the girls, was utterly beside the point. I don't think it's a stretch to say that in ancient times, and unfortunately in some countries today, the moment parents see that their baby has a vagina, she is viewed primarily as a matrimonial bargaining chip. Which isn't to say that marriage was a till-death-do-you-part arrangement even then. If it turned out a wife was infertile, the husband could return her to her family, or discard her completely.

These days, we can define marriage on our own terms, and everyone's marriage has its own rules. Sometimes one person is the breadwinner; sometimes both partners work, and sometimes they both lie around on the couch getting high and watching porn. But if there's one rule that defines many marriages, it's that you're not supposed to fuck other people.

I have to wonder, though, if our devotion to monogamy is realistic. Many husbands and many wives cheat. I myself was a serial cheater for the early part of my sex life. It seemed like an acceptable thing to do since pretty much

everyone I knew was also doing it. But some part of me cheated because I was afraid to be cheated *on*.

In a perfect world, there would be millions of different iterations of a good marriage. I think that if there was more than one socially accepted blueprint for a good marriage, maybe people could talk openly and stop being embarrassed or ashamed if their marriage functions outside the traditional ideology—or if their marriage is not functioning because they're trying to stick with a template that isn't working for them.

Take polygamy, for example. Early marriage was not at all opposed to polygamy. Personally, I'm intrigued by the concept. When I was a guest on *Extra* promoting my show *The Conversation*, I met the stars of *Sister Wives* in the greenroom. I hadn't seen the show but was fascinated once I discovered who they were.

"So you three are married to him?" I asked. "How does that work? Do you have children together? How do you explain that to your children? And what happens if he likes to stay in her bed instead of your bed, do you not get your feelings hurt? Do you have threesomes?" (They don't.) Polygamy is not for me, but I know a few people who swear by it. Same with open marriages, two people

who are into having multiple partners. I knew a guy who was in a relationship with a man and a woman, and they all lived together, a straight woman, a bisexual man, and a gay man. Actually, now that I think about it, that sounds completely exhausting; I can just about make time for one husband.

I should also take a moment to say that even though the prevailing cultural climate perpetuates the message that a woman isn't complete without a man, the whole idea that you're not whole or capable of genuine happiness unless you're married has done a massive disservice to women. Also, it's simply not reality.

In her powerful book *All the Single Ladies*, Rebecca Traister reported that single women are currently the most powerful political and cultural force in America.

No kidding.

Many women are waiting longer to get married *by choice*. Gone are the days when the first thing a woman considers when she meets a guy is whether or not he'll be able to put a roof over her head. I know many young women who provide a more than good life for themselves and look at potential mates through the lens of "What are you adding to my already pretty awesome life?" And

they're not averse to staying unattached for as long as it takes to meet someone who meets their standard.

This raises the bar for men.

Their paycheck is no longer enough to excuse a boring or obnoxious personality. If they're interested in a woman who has her own life and means of support, who's looking for a true partner, they're going to have to bring it and then some.

Culturally we're slowly beginning to acknowledge that getting hitched is not the only option for ladies. Of course, this makes many people nervous.

A woman with choices is a woman with power.

* * *

On June 2, 2006, after we'd been together five years and while Nick was on a break from the Strokes world tour, we took off last minute for Harbour Island in the Bahamas and got married on the beach, with two obliging locals as our witnesses. I was pregnant with twins and could just about squeeze myself into a very stretchy DVF beach dress. Our wedding vows were short but poignant. It was an intense moment for a super pregnant lady, and I sobbed uncontrollably the whole time.

This should be the part where I say we flew home after

our fantastically romantic wedding and lived happily ever after, but that's a Disney fantasy. The truth is, marriage is tough. Anyone who tells you it's a breeze is not your friend. Can we make a pact that we're no longer going to feel guilty for admitting that marriage is hard? A perfect marriage—just like a perfect life or a perfect body—is a myth. I was often unhappy in my first marriage, and there have been many times when I've been unhappy in my second marriage. The difference is that in my second marriage the happy moments mostly outweigh the unhappy ones.

I also don't want to negate the fact that I am not exactly a walk in the park. I fought the traditional idea of marriage in many ways and admit that I actively sabotaged my second marriage for many years, which was a nightmare for us both. It takes a certain kind of man to live with and love a lady like me, with strong views and ambition, but after sixteen years, Nick hasn't left me yet.

It's not a fluke that I married touring musicians. They go away a lot, and when they do, my time is my own, and I like that. Our twins were born October 19, 2006, the day Nick came home from an almost two-year tour with the Strokes. Being the excellent co-parent that he is, Nick took almost three years off work to raise kids with me,

during which time we drove each other to distraction by being constantly under the same roof, a first for us. We solved this problem by giving Nick his own "man cave" in our house; I'm sure he is just as grateful for it as I am.

One thing that has been key to our marriage is creating a true partnership. We are equal partners. Nick is just as responsible as I am for making sure there is food in the fridge, feeding the kids, scheduling their sports games, and checking to make sure they're wearing matching socks and sneakers. And yes, I know I am really lucky, but we have also both worked our asses off to get to this point, and let's not forget that he is also very lucky to have me as his wife.

Another cornerstone of our marriage has been being open to change. People can change, but only when they truly want to. I have had to learn to do things that every ounce of my being has not wanted to do and that are far out of my comfort zone—like apologizing for something that was only partially my fault, knowing that all that mattered was taking responsibility for my part. Personal accountability is one of the important things that needs to happen for relationships to grow together, NOT apart.

How long will our marriage last?

I have no clue. My husband said to me the other day, "I

can't believe I've been touching just your boobs for fifteen years." I laughed and said, "I know, what were you thinking? You were twenty-one and thought, 'I'm going to just touch this chick's boobs for the rest of my life?'"

I don't know if I think forever is realistic. I subscribe to the idea that as long as we want to be together, we'll be together.

Isn't the thought of sixty years overwhelming?

I take it a day at a time.

Being married is in many ways a trade-off. You sacrifice the adrenaline rush and sense of freedom that come from being with someone new for the security and comfort of someone who knows everything about you and loves you anyway. Today, I wouldn't trade that for anything in the world.

But of course, tomorrow might be a different story.

7.

Not All Teen Moms
Are Crazy

I was the original teen mom at a time when the only famous people in the UK were British royalty, some old male newscasters, Elton John, Duran Duran, and me, an eighteen-year-old pregnant talk-show hostess.

In my own way, I like to think that I challenged the perception of a teenage mother. The stereotype of a "teen mom" was a young girl who got knocked up because she made stupid choices, which was not the case with me or many of the young mothers I have met. I think it's often more complicated than that, but anyway there I was, happily pregnant with the child of John Taylor—

the man every girl in England wanted to marry. People were shocked that teen pregnancy could "happen" to a girl like me, that it must have been an accident. But make no mistake, my daughter was planned, and choosing motherhood at age eighteen is to this day one of the best decisions that I've made.

*　　*　　*

It was a year or so after John and I had begun dating when I started to get crazy tired and insanely nauseated. When it didn't subside after two weeks, I had a feeling I knew the source of my symptoms. So I went to the local pharmacy and bought a pregnancy kit.

On the short walk home I remember feeling as if the test was burning a hole in my coat pocket, like a secret begging to be told. With the urgency of someone whose life might be about to change irrevocably, I hurried into the loo, ripped open the test, and followed the instructions. Then those sixty seconds with my knickers around my ankles, my eyes fixated on the little window of the stick, were unbearable. In the silence of the bathroom, I could hear my own breathing and the traffic outside getting louder and louder until, at last, I saw two faint pink lines begin to appear.

I closed my eyes and opened them again to refocus.

There they were.

Not one but two VERY pink lines.

I checked the box repeatedly.

One line is not pregnant.

Two. Lines.

Two means pregnant.

I was pregnant.

Holy shit, I was pregnant!!!

My brain could not compute.

Then I started to rationalize that maybe I had read the instructions wrong.

Just to be sure, I took the second test in the box. There was no denying it.

I was pregnant.

<p style="text-align:center">★ ★ ★</p>

I don't think you should have to tell a bunch of people when you first find out you're pregnant. You don't owe that information to anyone other than the man whose sperm fertilized your egg. I suggest sitting with your news for a while. Is this a pregnancy that you want but can't have? Is having a baby not an option for you at this time? Do you want it but your partner does not? Or do you want it but

you're terrified? Are there no questions at all? Whatever the case, every woman should get to ruminate with this new information privately for a bit if she wants to.

Unfortunately, I didn't have that opportunity. The pharmacist where I bought the pregnancy test must have notified the tabloids, as my pregnancy news hit the press within twenty-four hours. It was one of the rare occasions in which the tabloids got the story right, and suddenly, before I had time to figure out how to process anything, the whole country had something to say about it. An eighteen-year-old sassy TV host and the thirty-year-old bass player from a hugely successful band having a baby together ignited the perfect tabloid storm. Up until that moment, I hadn't fully realized how famous I'd become, and it was a scary realization.

There was never a question whether we would keep the pregnancy. John was as ready as he would ever be. He'd run out of supermodels to date and had decided an eighteen-year-old TV host was the way to go. I'll never know what possessed him to make this commitment to me, but I'm eternally grateful he did.

The moment I learned I was pregnant, my sense of purpose shifted immediately. I felt that my body now had a new, extremely important job. It was no longer there just

for the fleeting pleasure of sexual conquests but to nurture and care for the person growing inside me.

I now think the nausea of early pregnancy is meant to prepare you for the shock of becoming a mother. If you can't handle the morning sickness, get ready because that's just the beginning. Your life is about to do a massive shape-shift, as will your body, your relationship, your career, your friendships, your freedom—your whole life changes. I'm not saying it's worse, but it is very, very different.

Like many professional women, I continued to work for the entire pregnancy. Since my job was hosting live TV, the simple act of continuing on with my daily life was interpreted as some sort of statement. The tabloid media went so far as to say I was a self-appointed teen pregnancy advocate, which was certainly news to me. I was just getting on with business but happened to be pregnant doing so.

Almost everyone close to me offered the following advice: "You will regret this, having a baby so young will ruin your life, don't do it." But I knew they were wrong, and I knew to listen to my own instincts, no matter what anyone else was saying.

★　★　★

My first baby arrived in the nick of time to literally save my life. John and I were madly in love, but we both had some untreated addiction issues—not the best circumstances in which to bring a child into the world. But the moment I was pregnant, I quit every activity that was unhealthy, and nine months, one week later, Atlanta Noo de Cadenet Taylor arrived and became my first true love. Even now, twenty-four years later, I still love her as much as I did the first time I laid eyes on her.

Atlanta was born in a hospital; this was before I knew about water tubs and hypnotic birth practices. John, who was by then my husband, was with me through all eight hours of labor. I vividly remember a moment when I felt as if I was leaving my body and looking down at myself giving birth. John was by my head, and Stevie Wonder was playing on the "Birth Mix" John had made especially for this moment. I hung out up there for a while, taking in my doctor, with his gloved hands poking around the entrance to my vagina, and the nurses close by. One nurse handed him an instrument that looked like giant cooking prongs, which he then inserted inside me. It seemed completely impractical to push an eight-pound-twelve-ounce person out of my vagina, and I wondered how this was going to work. But I reassured myself that millions

of women had done it before me, and I trusted that some kind of ancient birthing wisdom would kick in, which it did. I didn't look as if I was in pain; I looked quite peaceful as I followed the command to breathe in and push down on the exhale. I later learned that I was having what would be considered an out-of-body experience, or as I prefer to call it, a spiritual awakening. It was the first of many that being a mother would give me. As I pushed down one more time, I felt something hot and wet slide out of me and then heard a high-pitched little scream. It was strangely familiar and at the same time completely foreign. Seemingly without warning, I crashed back into my body and the reality that my girl, whose gender I had chosen not to discover beforehand, had arrived.

<p align="center">★ ★ ★</p>

I think birth is as wondrous as it gets. I am mildly obsessed with watching Instagram videos of water births and babies born with the amniotic sac intact. I keep trying to show my kids these miraculous clips, but they think it's inappropriate to see anonymous vaginas with babies' heads coming out of them, despite my reassurances that it's all natural and not creepy at all.

Women have such varied birth stories. I have one friend

who claims she had an orgasm while giving birth, which could not be further from my experience. Other women I know swear by the wonder and sanctity of a home birth. I've always wanted to know how much cleanup is involved in a home birth and how expensive it is to get the carpet cleaned with a nice organic, nontoxic cleaner afterwards.

I had a regular old medicated delivery, nothing orgasmic about it. But I'll tell you this: The moment I locked eyes with my little girl, I fell in love in the most complete and profound way imaginable. She was a little stranger yet someone I already knew and loved more than any other person on the planet. How does that happen? It's still a mystery to me. Despite my instantaneous love, my first thought as the nurse placed her, all bundled up, in my arms was, *Oh shit, I can* really *be hurt now.* I was terrified that loving this little girl as much as I did could cause me a lot of pain. Yes, loving fully and completely is a risk, and there are times of immense, crippling sadness and pain, but without question, giving birth to her was one of the most profound, awakening moments of my life.

At nineteen, I obviously had no idea what it meant to become a mother. Most people don't. A friend told me a story about coming home from the hospital with her new-

born in the car seat, and just staring at her thinking, *Now what?* EVERYTHING comes with an official manual, except a baby. My only concept of parenting came from my own mother, who was and is one of the most loving and affectionate women I know. But while I absolutely learned how to be compassionate and kind and how to make a killer roast chicken from her, there was a lot about being a mother that I needed to learn. As an adult now and the mother of three, I can only imagine how petrified my mother must have been after my parents' divorce, finding herself suddenly alone and largely responsible for two young children who were not easy to deal with, I'm sure.

The day I saw those double pink lines, I knew without a doubt that my child was going to have a different experience than I'd had. An unfamiliar feeling came over me, one that I've come to recognize as a sense of purpose. It was clear to me that my reason for being on the planet at that point in my life was to be this child's mother.

<p style="text-align:center">★ ★ ★</p>

Even though I have not one single regret about choosing motherhood at eighteen (or again at thirty-four), I recognize that becoming a mother is not for every woman. I've interviewed and known a lot of ladies who are very

ambivalent about having children. Many of them say that they feel enormous pressure and judgment from family, friends, and society to become a mom.

That a woman's "happily ever after" might not include children is threatening to some people. A woman who doesn't want kids doesn't fit with our family-values-oriented society. People assume something must be "wrong" with her and make assumptions about her fertility or about her sexuality. They call her selfish, or even more offensive, she can get called "extremely ambitious," which bizarrely is still considered a major insult for women. The truth is that having kids is not for everybody—and respect to those who are self-aware enough to know they aren't suited for it.

I wish that all mothers felt more comfortable honestly speaking about what it means to bring another human being into this world. The world expects women to behave as if the arrival of a baby is always a joyous event, but the reality is often way more complicated than that.

If you're flat broke, in an unhealthy relationship, single and without resources, or you didn't plan on getting knocked up, then finding out you're pregnant isn't great news. I was extremely fortunate in that both times I was pregnant, with Atlanta and my twins, I was financially

secure and partnered with someone who was fully on board with the idea. I don't take any of that for granted, not for one second.

It probably comes as no surprise that I am a fierce advocate of a woman's right to choose. By that I mean a woman's right to make choices about every aspect of her life, including her reproductive health. I also believe that instead of shaming women and girls who, for whatever reason, find themselves with an unwanted pregnancy, we must support them without judgment.

I say this because I was one of those women, and having an abortion was a difficult enough decision to make without the added pressure of being shamed or questioned by my family or community.

Fortunately, I lived in a state where women have access to the reproductive care they need through health insurance or Planned Parenthood. Under the jurisdiction of President Trump, this may all be about to change—women's reproductive rights are threatened on a national scale, which is something that keeps me up at night.

I have been inside many abortion clinics, both during my own visits and those of my friends whom I accompanied for support. I had my first abortion when Atlanta

was a child. I got pregnant with a partner who was adamant about his wish not to become a father. I was madly in love with him, and there was nothing I wanted more than to have a child with this beautiful, spirited man. But when I told him the news, he straight up said, "My dad split when I was a kid, and I don't want to be an absent father. Please do not make me do this until I'm ready, and I'm really not." He was very clear about not wanting to be a father. I agonized over the decision, knowing that at eight weeks pregnant I didn't have much time to decide.

Choosing to terminate the pregnancy was hands down one of the hardest choices I've ever made, and I deliberated up until the last possible moment. I was already a mother, and I knew what it was like to carry and birth a little person. But I loved this man so much and therefore had to honor his feelings and wishes, not just mine.

I believe that the decision to end a pregnancy is ultimately a woman's to make; after all, she is the one carrying the embryo inside her body. In this case, however, the moral and practical decision was made with huge consideration of my partner's wishes. I can imagine times when I would not have been so accommodating, but that was the right choice for me and him at the time.

★ ★ ★

IT'S MESSY

Getting pregnant at thirty-four was very different from getting pregnant at eighteen. When Nick and I had been together for five years, we decided we were ready to be parents together. He was on tour at the time, so we would have what we jokingly called ovulation parties. Once a month, I would show up in Antwerp or Manchester or Saint Louis or some other out-of-the-way town that I would otherwise never visit, and Nick's bandmates would know why I was there. I would keep Nick captive in his hotel room for days, perpetually postcoital, my butt propped up on a pillow, my legs against the wall. Gravity, I am convinced, assisted in me getting pregnant.

Twins run in families, but they skip a generation. Apparently, there were twins on my father's side, which I did not know about until I called my grandmother in a state of shock and fear over the news my doctor had just given me. I knew what it was like to raise one child. But I couldn't imagine what it would be like having two babies at once, and if I'm honest, it took me almost three years to get with the twin program.

What is it like to plan for one child and get two or even three?

It's not like getting a couple of extra burgers in your order by mistake; it's another life or two to take care of

for at least eighteen years. Nick, who was all of twenty-four and had never even held a baby before, was ecstatic we were having twins. I, on the other hand, was filled with complete terror and fear.

Maybe my first pregnancy was easier because I was eighteen and there was only one baby, or maybe my memory of pregnancy with the twins is just stronger because it's more recent. But my second pregnancy felt like a hormonal grenade going off in my body. I knew the day we conceived because within *hours* I started to feel weird. Mildly nauseous and light-headed.

And I still had nine months to go.

I was not what you would describe as a happy pregnant person. Not surprisingly, I'm not alone.

I know many women who hated being pregnant, but they just don't feel comfortable sharing that truth. There is a ton of mommy shaming that goes on, and it needs to stop. If you are someone who barely notices being pregnant, then I'm happy for you. But if you aren't, that has to be okay, too.

Another suggestion: let's rename morning sickness, as that can be quite misleading. During my first pregnancy, "morning sickness" lasted all day and night and ended at three months exactly. John, my then hubby, brought me

all the foods I was craving and could keep down, mostly bread and cheese. I remember thinking, *I must never do this again.* But sixteen years later, there I was again.

For those of you who've never experienced a twin pregnancy, let me enlighten you on some of the finer points.

By the end of my pregnancy, I was so huge that I literally had to be rolled off the bed in the morning. I couldn't see the ground two feet in front of me. With every step, I felt as if I was going to tip over and fall on my face. At six months pregnant, I decided to accompany Nick on tour in Scandinavia, which I had no business doing, as I was so enormous that I couldn't fit in the bunk bed on the tour bus. I had to sleep in the back lounge—a problem because the back lounge is the place where band members retreat to play video games and smoke, which I wasn't able to tolerate. One whiff of smoke made me vomit immediately. I'm sure they were secretly counting the days until I went into labor so I would leave and go back home to LA.

My biggest worry was that Nick would still be on tour and wouldn't be in LA for the birth. I had gotten pregnant with him on tour, and he had been on the road for more than eighteen months. I was praying he would make it back on time.

On October 18, 2006, at 3:00 p.m., Nick returned from

an almost two-year-long tour. He was bedraggled and exhausted. At 10:00 p.m. that same day, those babies, whom I had been begging not to come until their daddy was home, decided it was time, and I went into labor, delivering on October 19 at 8:00 p.m. after ten hours.

How it works with a vaginal twin birth is that once the first twin comes out, there is a limited time window in which to deliver the second baby before the cervix starts to close. My ob-gyn is a badass motherfucker who at eighty years old has seen more famous vaginas than Jack Nicholson. He's an old-school doctor and one of the few who still deliver twins naturally, and he was the reason, when I got pregnant, that I moved from New York City back to LA.

I had a vaginal twin delivery, which in LA is so rare that literally twenty-five people came into the delivery room at Cedars-Sinai hospital to watch me push them out. Ella was born first. She was fully cooked and ready to go. Our son, Silvan, was breech and not ready to come out. He could've done with a few more weeks, for sure. It took both my doctors working expertly together to manually turn him inside my belly, and Dr. K., with his gloved arm inserted halfway up inside my vagina, grabbed what

he later told me he hoped were two feet and not a foot and a hand, to pull my blue, baffled, and quiet-as-a-mouse son out into the bright, loud world.

He looked so different from his sister. He had no eyebrows, no eyelashes. He was four pounds and looked like a tiny alien. He spent his first seventy-two hours in an incubator just trying to get with the fact that he was now out of utero and in the world.

When it came to naming them, I was hell-bent on giving them their own identities. I'm not particularly into the tradition of naming babies after dead people. I know a lot of people do it, but it's not for me. Also, how do you decide whose family member gets honored in the lineup, and what billing does that person get? First name or middle name? Just too many opportunities for a fight, if you ask me.

Nick and I both agreed on Ella Grace, but it took a few months to decide on naming our boy Silvan. We just called him "boy" or "him" for three months until the deadline approached when you have to legally register a kid or they don't officially exist. Silvan is the perfect name for him. His dad came up with it. *Silvan* means "man of the woods," and that is where my son is most happy.

* * *

True to their first moments in the world, Ella is a kid who gets up at 6:30 a.m., makes breakfast, packs the lunches, gets dressed, and then wakes everyone else up, including Silvan. Ella is the CEO of our home, and I'm not worried about anything not going according to plan with her in charge.

Atlanta has grown into the kind of girl whom, were she not my daughter, I would absolutely want to be friends with. I'm still navigating how to be a mother to an adult daughter, and she's still navigating how to be an adult daughter to her mother. From the time she was two until she was ten, it was just the two of us. We were a small but mighty team. So when twenty-one-year-old Nick entered the picture, she told me, "Mom, this guy is like, ten years older than me. It's just weird." I guess it has been a unique situation for her having a stepdad who is a man the age that many of her friends date.

I wouldn't say Atlanta and I have a codependent relationship, but it's perhaps right on the cusp. When she was nineteen—the age I was when I gave birth to her—she informed me she was moving to New York. I had a moment of panic where I wanted to say, "I'm not sure that's the

best idea!" or "What about your little brother and sister? You'll miss them growing up." But I knew better than to clip her wings. At some point all parents have to trust that we raised our kids well, and they will go on to use the tools we gave them. Rather than say anything to stop her, I heard myself saying, "I trust your judgment, my girl. How can I help you make this move?"

That is years of therapy and recovery in action right there . . .

Baby Chaos: The First Year of Motherhood

The media's version of a new mom is a tiny bit frazzled but otherwise calm, happy, and fulfilled. You know her—she's the perfect modern mother who shows up in TV adverts, rom-coms, and style blogs. She has lost her baby weight and is always holding a smiling, toothless cherub with a bit of photogenic drool on his chin. This couldn't be further from reality, yet the fantasy persists. Babies are like this once a day, maybe. The rest of your daily life with a baby is a tornado of sleep deprivation,

feeding, changing diapers, giant sore nipples, breast-milk-soaked bras, along with the most intense love you will ever experience—love so deep it verges on scary.

The perfect-mother scenario exists even in maternity wards, where everyone somehow expects you'll just know how to handle the things that no one talks about. Practical things, like how to clean a baby's belly button when the cord is still attached and looks like a burnt piece of bacon. Or how about your baby's first shit, meconium, which is like greenish-black tar, evidence of the last supper inside your womb? No one told me about that. No one told me about the importance of regular burping. I didn't burp Atlanta for the first three months of her life.

When you buy a new car, they put a lovely little book in the glove box explaining what all the warning lights mean. IKEA furniture comes with instructions. But you leave the hospital with best wishes and zero advice.

We go from not being a mother to being a mother in a very short period of time, and our main task—how am I going to keep this tiny helpless human being alive?—sounds simple, no more complex than taking care of a houseplant. Just add clean diapers and milk eight times a day. But keeping a child alive is not so simple. In the beginning, I checked on Atlanta every fifteen minutes to

make sure she was still breathing. I imagined it would be different with the twins but no. All day long, whenever they were quiet, not moving, or sleeping for six hours, I was wondering, *What the fuck is wrong with you?*

Or they were screaming their heads off, and I was wondering, *What the fuck is wrong with you?*

Either way, I was paranoid and exhausted, which was not a good time for anyone.

Raising a child is the hardest job I've ever had, both physically and emotionally. Unlike my other jobs, in the early days there was never a time when I could unplug and relax for the day. I had no idea that I was signing up to be on call 24/7 for a minimum of two decades. Which, come to think of it, is probably why there's no instruction manual. If someone wrote the truth about what we were in for, women the world over might be more likely to think even longer and harder before choosing parenthood.

★ ★ ★

When it comes to parenting, and especially motherhood, people have a lot of opinions. And that's putting it mildly. But two areas where people seem to have the most and strongest opinions are childbirth options and breastfeeding.

Are you breastfeeding?

Did you have a natural birth? Because any other kind is just not safe for the baby.

How long are you going to breastfeed?

Do you pump?

Why didn't you do a water birth?

Are you supplementing with formula?

You are? That's not a good idea.

Listen to different opinions, but please never let anyone tell you they know the only way to do it, because what works for them may not work for you.

When my milk came in, my boobs stretched to the point where I thought they would pop. Suddenly they were filled with, I don't know, a pint of milk each? They were a GG cup, which is a size I didn't even know existed.

It was an insane amount of milk; my boobs were heavy and rock hard. Friends tried to be helpful, suggesting things like putting cabbage leaves on them to help relieve the pressure, or warm compresses to help the milk come out. But nothing helped except feeding the babies, which was pretty much all I did for the first year my twins were alive.

I tried to go back to work when Ella and Silvan were six months old. I remember photographing a well-known

actor for *GQ*. By the time we got shooting, I was past due for a pump. I remember looking through the lens and seeing his handsome face contort in disgust and confusion. I put my camera down.

"Are you okay?" I asked.

"Um, something is happening to you . . . Something's happening . . ."

I had milk dripping out all over my shirt and onto the floor.

I shook my head in disbelief and excused myself to hand express in the bathroom.

By that time I'd experienced all kinds of weird bodily fluids and excretions in new and horrifying ways—pee in my eye, poo in my hair, and explosive diarrhea all over me. I can't tell you how many times Nick and I would be sitting together on the couch while I was breastfeeding and I would accidentally squirt him in the face with breast milk as if I were wielding a water pistol.

My life went from being fully focused on a career I loved to spending my days sitting in a god-awful-pink-corduroy-covered breastfeeding chair, wearing a milk-stained "pumping bra" with two holes cut out over the nipples where the pumps attach to my boobs. There is no way to NOT feel like a cow when you are attached to a

milk pump, listening to the whirring of the machine as it relentlessly sucks your nipple into the plastic tube and squeezes every drop of breast milk into the bottle. Yes, I know it's beautiful that my body was sustaining the lives of my babies, but I also experienced a monumental identity crisis and with it an overwhelming feeling of loss.

As the weeks turned into months, it felt as though my sense of self was also getting sucked into the milking machine, until I began to not recognize myself and longed for something, anything, familiar.

About the third or fourth month in, after I'd adjusted somewhat and my babies were sleeping for at least a few hours a night, I looked at these tiny people and was overwhelmed with these thoughts: *I cannot return you. This is it. There is no going back. You're mine, and I'm yours, and we are not going anywhere. If a pet is for life, then this is some other-level serious shit.*

The moment that realization began to hit me with the twins was also when I was starting to experience the beginning stages of what would become some major postpartum depression. As much as I loved Ella and Silvan and wanted to be with them, I also wanted to get away from them. My general attitude became "Whatever, I don't care." I had a complete lack of interest in anything ex-

cept sleeping. At first, I mistook my apathy for the normal shock of being a new mom. But soon I began to see that my low energy and lack of interest was a red flag that something was very off with me.

Fortunately, when I couldn't function very well, Nick was there. He was an involved father from the beginning, unlike a lot of the men of my dad's generation, who expected to be awarded the Congressional Medal of Honor for changing a diaper. Men in Nick's generation are generally more involved. I see these guys at playgrounds all over the city wearing BabyBjörns and sometimes shepherding multiple children. Nick was, and is, just as involved as I am, and I would never have been able to get through those tough first years (my PPD lasted for *two years*) without him.

Postpartum depression is quite common—one out of eight mothers experiences some form of it—but moms often tend to avoid talking about it because it's distressing and horrifying to think we're already messing up motherhood. Unfortunately there is still so much stigma around PPD, which needs to change.

PPD is thought to be caused primarily by what I believe is a clusterfuck of hormonal changes and the general upheaval of life as you once knew it.

PPD is a tricky thing to self-diagnose. It ranges from mild to extreme. Like alcoholism, when you have it you tend to be the last to know about it. Someone in the throes of depression, especially a new mom, often can't bear the thought of having to deal with yet another impossible-seeming thing. If a friend suggests a new mom might be depressed, our knee-jerk reaction is likely to say, "You think I'm depressed? What the fuck do you know? I just had a baby. I'm just tired."

But a trusted friend or in extreme cases a doctor really can help you discern whether you are just tired or dealing with something more serious, like PPD.

Here's a trick I've learned from my girlfriends who've survived it and come out on the other side to tell the tale: If you suspect you might be prone to PPD, ask a few people you trust to keep an eye on you *after* you give birth. That person watching out for you might not be your partner or husband. It might be a best girlfriend. Tell your friend, "I'm asking you to pay close attention to my mental health because if I'm down the hole, I won't be able to see it." To your partner, family, and friends, your PPD symptoms may seem as if you're just suffering from lack of sleep, or maybe you're just going through some hormonal changes. But it could be way more serious, as it was for me.

When the news reports heinous stories of women microwaving their kids or driving them off a bridge, my first thought is to wonder whether the women had PPD or any mental illness, which pregnancy and postpregnancy hormonal changes can often trigger.

When I was in the throes of PPD, the only thing I wasn't apathetic about was my career. I began obsessing that I would never get hired again and that my life would be nothing but sitting in a stained old pink-corduroy-covered breastfeeding chair. A wise friend tried to reassure me. "But, Amanda," he said, "talent doesn't expire. And you are very talented." I held on to that sentiment for dear life, and thankfully, even though my depression made me feel doomed to failure, my friend was right.

I think part of the reason I became hyperfocused on my career was that I just wanted something that felt familiar to me. I wanted so badly to feel normal again. I didn't feel like myself. I didn't look like myself. My life in no way resembled what it had been before I gave birth, and I missed myself and my previous life, like crazy.

Regardless of the fact that PPD is common, most women suffer in silence. There's still so much shame around not being the joyous and natural mother that we

are "supposed" to be. Our culture conveys to us that being in love with our newborn should be all it takes to make us blissed out. But we're complicated human beings who—guess what?—can be in love with our babies and still feel anxious, numb, sad, and restless. We can still wonder what in the hell we've done by having a baby. I can't imagine my life without Ella and Silvan, and I can't imagine one without the other. Ella without Silvan or Silvan without Ella doesn't make sense. So many times I've thought, *Thank God I've got them both.*

And still, I was depressed.

It's no wonder mothers are reluctant to admit they're struggling. Even the pros don't seem to fully understand all the influences that can make a woman vulnerable to PPD. The Mayo Clinic's website, for example, offers a list of risk factors for PPD that barely acknowledges a new mom's socioeconomic circumstances. At the very bottom of the list, after such factors as a history of depression, bipolar disorder, PPD after a previous pregnancy, family members who've suffered from depression, "stressful" life events (complications during the pregnancy, job loss, illness), the baby's health, difficulty breastfeeding—after all of these come "weak support system" and "financial problems."

It seems odd to me that having a family member who's suffered from depression is a greater risk factor than solo parenting or being broke. Even the professionals minimize it, leading moms to feel that—despite the hard realities of how they're going to actually feed this baby once he's off the boob, or how they're ever going to have time to take a shower or a nap with no family or friends around to watch the baby for a few hours—they should be filled with maternal joy!

I want to clarify that socioeconomics are not everything when it comes to PPD—all women from every walk of life are vulnerable. In 2012 I interviewed my beloved friend Gwyneth Paltrow on *The Conversation*, and we discussed how she'd suffered from PPD after the birth of her son, Moses, in 2006.

"I felt like a zombie," she said. "I felt very detached . . . I just didn't know what was wrong with me. I couldn't figure it out. My husband actually said, 'Something's wrong. I think you have postnatal depression.' I was mortified. 'No, I don't!' And then I started researching what it was and the symptoms and I was like, 'Oh, yes I do.'

"We think that it makes us bad mothers or we didn't do it right, but we're all in this together. I never understand why mothers judge other mothers. Can't we all just

be on each other's side? It's so hard anyway. Can't we all help each other get through it?"

Makes complete sense to me, right?

It took me about five years to really get my head around the fact that I had twins. Until then I was just in survival mode. A big part of motherhood is about managing time, and with twins your workload is essentially tripled: there was my relationship with Ella, and my relationship with Silvan, and Ella and Silvan's relationship with each other. Not to mention their elder sister, and then let me not forget my baby daddy. The logistics become mind-boggling. Most days it's a coin toss whose needs get met first. She needs to go potty, but he spilled apple juice all over himself and the floor, and both need help now. By the way, that's when I end up getting real close to losing it. When I feel that happening, I tell myself, "Put the baby down and walk away." That's another piece of advice that should come in the instruction manual.

It's saved me many times.

Another fairy tale about being a new mother is this idea that your body is supposed to snap back like a rubber band the moment the baby comes out. This fantasy is perpetuated by—well, who ISN'T it perpetuated by?

I did a photo shoot with my newborn twins looking super put-together and manicured, with a fresh face of makeup. "The greatest thing you can do when you love somebody is to make another human being," they quoted me saying on the cover. I meant what I said, but the airbrushed picture didn't tell the whole story. What you didn't see were my leaky boobs, my stretch-marked belly, and the ten stitches that were firmly placed inside my vagina to sew me back to a reasonable size. I was so pleased to see Kate Middleton, Duchess of Cambridge, the day after she gave birth, posing for pictures with her postbaby belly on display. Love her for that share.

Almost no one gets her prebaby body back within weeks. And by the way, what's wrong with taking some time to let your body—*which has just constructed an entire human being*—just be? Every media outlet that perpetuates the notion that the only beautiful female form is the one that looks like it's never given birth should be called out. All their insane coverage about new moms who look as if they found their infants on the doorstep instead of experiencing labor and delivery does nothing but reinforce the unacceptability of the postpartum female body, which can be bumpy, lumpy, leaky, and floppy.

We need to change the standard of what is socially

acceptable postpartum. I love the movement on Instagram and Tumblr where new moms flaunt bodies that are not lipo'ed or dieted or retouched. This is what your body looks like after you've had a baby, and guess what, people—it's a miracle and should be honored as one.

We need to give women a lot more room to be imperfect—and the permission to admit feelings that don't necessarily fit with the perfect-mother ideal. New mothers need to be recognized as the superheroes and warriors they are and to be supported instead of scrutinized. Perhaps then they wouldn't feel so alone.

Of course, there are many moments that make all the crazy beyond worthwhile, like when you're breastfeeding in the middle of the night and you look down at this tiny, perfect person who's looking at you, studying you, who already loves you regardless of how many times a day you're crying, who doesn't care that you haven't brushed your hair or shaved your legs in forever. It's like when you first fall in love with someone and you never want to stop looking at them.

Only better.

How to Parent in the Time of Trump

M om, what's a pussy?"

"Umm, in what context do you mean?"

"My friend Noah says that Donald Trump grabs women by the pussy."

This was a question posed to me by my ten-year-old son the day after the Trump Pussy Grabbing Tape went public.

"The word pussy, when used in the context that Donald Trump used it, is slang for a woman's vagina," I say. "However, that is not the worst part about what you told me. Any idea what I'm referring to?"

"That he *grabs* them by the you-know-what?"

"Yes, exactly. It's never okay to grab anyone, especially by their vagina or penis."

Fuck. I was really not ready for THIS one, but is there ever a best time to explain something like this to your kids? And then there was also the explanation of "Pussy Bites Back" when a mere forty-eight hours later, women and girls around the world, myself included, adopted that as our slogan in retaliation for Trump's misogynistic rant.

I did not have this discussion on my parenting to-do list. The discussion did, however, open up a dialogue among many mothers I know about the challenges of raising kids in our current political climate.

I like to think we are the living example of a family that operates by a very specific code of conduct. We discuss race, gender, identity, stereotyping, bias, and equality in some capacity almost on a daily basis.

When one or more of these themes come up, we address it in the moment. Ask my friends who have my kids over for a meal—Ella and Silvan will point-blank call people out when they pick up bias of any kind, sometimes to the embarrassment of their host. A recent example is when my son had lunch with an extremely well-respected

film director and asked him why he'd never cast a woman in a lead role in his massive film franchise.

My kids see feminism in action every day, and leading by imperfect example is how I'm raising them.

★ ★ ★

If there was anyone primed to raise their kids feminist, it was me. My parents treated me no differently from my brother. I was raised to believe I was capable of doing anything I set my mind to. Despite the gender stereotypes in the '80s, my race car driving dad taught me that I could do whatever my brother could. My dad showed me how to ride a motorcycle when I was six and said I would never need to be a passenger on some drunk guy's bike, that I could put the drunk guy on the back and ride that motorcycle to safety if need be.

I don't raise my daughter differently from her twin brother, to the point where she only wanted to wear his clothes—sweatpants, baggy T-shirts, and high-tops—for a year straight. She claims it's because she needs to be "comfortable and functional," and who can blame her? I would wear a tracksuit seven out of seven days if I could.

No question there are more opportunities for women

than ever before to create a life that is authentically their own. And yet at the same time, the patriarchy is working hard to make sure we stay stuck in the same old gender roles, even if there is a lot of confusion about those roles right now. Women's roles within the family and workplace have changed so drastically over the last few decades, which is huge progress—but this has also left both men and women uncertain at times about who is doing what.

It wasn't all that long ago we were being burned as witches, viewed legally as property, and sent off to mental asylums if we disagreed with our husbands. So it's no wonder that we're still trying to carve out a place for ourselves in the modern world.

My daughter is a prolific writer, and not long ago she wrote a paper for her school called "Sexism: It Is Everywhere," a persuasive essay about how Hillary Clinton, as the first female president, would make it her priority to combat sexism. She then went on to give some very accurate examples of gender stereotypes and the ways in which girls are sexualized in everyday life, citing a trip we took to Target and how disgusted she was to discover that all the girls' superheroes outfits are basically pink crop tops and underwear.

My son is obsessed with sports, but unlike a lot of his

peers, he's also very female sensitive. At bedtime recently he was reading a book and said, "Mom, you'll like this book because the girl, who's the main character, and the boy are friends and it's not like they're boyfriend and girl-friend." I was ecstatic that he remembered my opinion that the sole purpose of girls in narrative should not be simply to provide the boy with a love interest.

The reality is that parenting has always been compli-cated, but given the political landscape today, it feels trick-ier than ever. The Parenting 101 handbook needs a major update on a list of things, like how to navigate the pros, cons, and many perils of appropriate internet usage. Any child who knows how to work an iPad, which is most of them, can with a tap and swipe see our pop culture icons in various forms of undress. It used to be that only the girls with no talent had to rely on being half-naked to get noticed, but now even the ones who are already a huge success have adopted this approach.

This makes it all the more challenging to raise a daugh-ter to believe that using her brain and working hard to become successful are not mutually exclusive. It's close to impossible when almost all the messages delivered to her say the opposite. So what DO you do and say?

First, I want to acknowledge that I was the queen of the

barely there outfits, and boy did they have the desired effect. Especially at age fourteen, hitting up some club with whatever cute band boy of the moment, wearing a fishnet catsuit with denim hot pants. YESSSS! This worked like a charm every time, and continued to do so for years to come. So, I get it. I really do. And maybe because I came to realize that my own urge to wear less was an attempt to disguise my monumental desire for attention and love, I have a preconceived idea and projection about why every other talented girl is also half-naked.

Are Ariana Grande, Beyoncé, and RiRi often emulating strippers onstage because they're celebrating their slammin' bodies? Which would be fair enough. Or do they all possess some deep need to be desired by everyone who lays eyes on them? Is there an unspoken competitiveness with other women? Forget being the fairest of them all, today it seems like it's about being the most fuckable of them all, and if you made me pick one, I would have to say RiRi does it for me.

Anyway, here's how I address this issue with my kids when we see one of the aforementioned half-naked singers.

Sometimes I make light of the whole thing and joke, "I'm so distracted by RiRi's boobs I can't focus on her incredible voice!" I draw attention to it so as not to nor-

malize it. Occasionally—and this is when co-parenting gets tricky—Nick will chime in with "I think RiRi looks GREAT in her underwear, what's wrong with that? She's just performing." He's not wrong, but I always want to go on record as pointing out that being almost naked should not be a necessary component of being a successful female performer. And in fairness to RiRi, she often wears a dude-like suit onstage, so at least she's mixing it up.

<p style="text-align:center">★ ★ ★</p>

My kids also educate me. I'm aware we're living in an extremely PC culture, where it's easy to offend people without meaning to. Part of that updated Parenting 101 handbook should include making sure our kids understand that there are dozens of gender identities. When a boy shows up to school wearing a dress or big hoop earrings, Ella and Silvan don't give a crap. Their attitude is just "Oh, Rafi wears dresses, Mom. That's his style."

Occasionally my son will ask me, "Why should I let Ella go first? Or why should I hold the door open for Ella—if we're all equal why shouldn't she hold the door open for me?"

He has a good point.

Are traditional manners like a guy holding the door

open for a female, or taking her coat just some shit from the '50s? Can't a woman open the door herself and hang up her own coat?

She sure as hell can, but it's nice to have someone who is courteous, and I'm still teaching Silvan the fine line between chivalry and insulting an empowered woman.

I want to raise kids who are curious and engaged with the world around them, and who are aware that the privilege they were born into is not the typical experience for most kids, that they should not take it for granted and should always look for opportunities to use the advantages they've been given to help other people.

I guess the proof is in the pudding—we'll have to wait until they're grown-ups to find out what effect we've had on them. In the meantime, I try not to worry that every little misstep will permanently ruin my kids. There will be plenty of opportunities to set things right and just as many opportunities to fuck things up again. And I've come to accept, that's just parenting.

Be a Girl's Girl Every Day and All the Way

I've always been what would be considered a girl's girl, and if you're reading this book, chances are you're one, too. I live and die at the altar of female friendships. Too much emphasis in our culture is placed on finding romantic love, but I've always believed that it's the platonic love of our girlfriends that is crucial to long-term sanity and success. That's certainly been the case for me. After lovers have consistently disappointed you, and your family has yet again proved to be impossible or unreliable, your girlfriends are there to hear you out, support you, advise you without judgment until death do you part. My

BFFs are as much my soul mates as my lovers have been. Even without the sex part, the connection and love is just as deep and should be honored and valued as such.

For as long as I can remember I've always had intense, complex connections with my girlfriends. My first best friend—and first kiss, as well—was another little girl called Amanda. We were nine. She was American, and her family had moved to London for her father's work. We were inseparable, like Bonnie and Clyde, if Bonnie and Clyde were two little badass tomboys. Amanda had a thick New York accent and the latest American swag. She introduced me to scratch-and-sniff stickers and Hello Kitty everything, which I still have a penchant for all these years later. She saw me and I saw her for exactly who each of us were, in the way that tween girls often do.

I became completely obsessed with Amanda, the first of many codependent relationships I would have. Kiss chase was a popular playground game during the height of our mutual obsession, the UK version of traditional tag. It was challenging when Amanda and I both played because if anyone tried to kiss her or me it caused a problem in our relationship. One of us would always end up feeling upset and rejected, and an afternoon of attempt-

ing to "make up" would ensue. This became a dynamic that would play out in all my subsequent relationships, so there must be something about that tension that I enjoy.

Have you ever asked yourself, what is the measure of a true friend? Is it someone who will buy you a box of tampons on the way over to visit? Someone who will bail you out in a crisis (sometimes literally)? Someone who will proudly stand next to you at an important event, even though you haven't shaved your legs or armpits in an obscene amount of time and unquestionably have some major body odor? Sometimes it happens when you use all-natural antiperspirant. A small price to pay for breast health, I think. Yes, all of the above, as my friends have done for me, and I have also done for them.

I cannot tell you how many times my girlfriends have figuratively talked me off the ledge. They have filled the well of unwantedness at the center of my being in a way that romantic relationships never have, and helped heal my fractured heart in a very special way. At every stage of life, my ladies have held me up when I was going under.

When I was shipped off to a boarding school called Benenden at age eleven, the only thing that saved me was the extraordinary sisterhood of my schoolmates. Many

of the girls I bonded with came from the kind of so-called privileged backgrounds that commonly meant a lot of money and not a lot of love.

Contrary to reports in the media that Courtney Love and I were lovers, I've only kissed two women (both times when I was seriously inebriated), but at boarding school it was the norm to have innocent "crushes" on other girls. I formed very intense friendships at school. It was not unusual to share your bed or bathe with your best girlfriend. It was comforting to lie next to someone else, to feel another heartbeat, to not be alone. Being sent away to boarding school when your parents are in the middle of a heated divorce is comparable to suffering a massive loss. Or at least that's how it felt to me, the eleven-year-old girl who just wanted to be at home, play with her hamster, and read Enid Blyton books about magic forests. I still think that loss of any kind is one of the hardest things to navigate in life, but the support of your best girlfriends makes it a bit easier to endure.

★ ★ ★

I was twenty-one when I met Victoria Mahoney in a friend's kitchen at a random get-together. Today, twenty-three years later, she is still one of the most significant

women in my life. She's been my emergency contact for more than two decades—that right there tells you how serious and committed our friendship is.

For many years people naturally assumed that Victoria and I were a couple. "Oh, those kids have two moms," we often heard. Or maybe they thought that Nick had two wives. The truth is a lot less scintillating: it really does take a village to raise kids, and Aunt Vicky is a crucial part of our family's DNA.

Victoria was the prototype for the first healthy relationship I ever had. She taught me about authenticity and honesty, about allowing another person to see who you are, about being vulnerable, and acknowledging your faults when you fuck up, about how to let someone love you even when you feel like you're not worth loving. Without going through the learning curve with her, and trust me when I say there was a major learning curve, I wouldn't have known how to have other friendships and/or romantic relationships that were healthy. I didn't know what healthy love looked like until I met her.

When I was twenty-two, after my divorce from John, I moved into a little house in the Hollywood Hills with my daughter Atlanta and filled it with a petting zoo's worth

of bunnies, birds, cats, and dogs. Who doesn't need all those emotional support creatures after a big breakup?

Our new home was also filled with my newfound girlfriends. There was often someone sleeping on our couch or crashing in the guesthouse. When someone was in trouble, having a hard time, or in need of a safe place to go, they knew my home was the place they would be fed well and given a bed to sleep in, sometimes for months at a time. I loved having company, visitors to hang with and process the day's trials and tribulations.

It was during this time that I became friends with Tracy. She was an end-of-life at-home hospice worker who spent her days with people who were weeks away from dying. I had never met anyone with a job like hers, and I was fascinated by the endless stories about her patients and their lives. Tracy lived in my guesthouse for a year in exchange for babysitting Atlanta. She would come home at night and tell me stories about her incredible patients and the remarkable insights many of them experienced so close to death, what they wished they had done and said, as well as their regrets and loves. Having friends like Tracy, with completely different life experiences than I do, makes my life richer. Who wants to sit around a table with a bunch

of people with the same opinions at the end of the day? I've learned the most from engaging with people who think completely differently from me—that's where the real discoveries are possible.

Every Sunday I held an informal open house, and my ladies and I would cook, laugh, and chat about everything, and I mean everything, going on in our lives. My home was an ongoing feminist sanctuary for a group of girls just trying to work it all out. Ten years later *The Conversation* was born out of those ongoing chats happening in my own living room.

★ ★ ★

One of the biggest gifts of friendship is being able to witness my friends live their lives up close, through the celebrations as well as the hardships. I was often alone after my parents' divorce. I had no one to help me learn how to navigate the world. I learned how to get through life by watching my friends. That, and reading autobiographies about women I admire and asking successful women a lot of questions about how they made it.

When my friend Gwyneth separated from her then husband, I saw how it really was a choice to be kind and

dignified during a separation, instead of behaving in a way that makes the experience harder on everyone, especially the kids. Watching Gwyneth and Chris co-parent like champions set a new normal for me, and for any of us who may one day separate. To see my friend work her ass off to reduce the potential trauma of divorce on her kids has been nothing less than profoundly inspirational. The woman deserves praise and immense credit, not criticism and mockery aimed at her for "consciously uncoupling."

My girl Brody Dalle and I have lived through similar traumas (details I won't go into here) and understand each other without needing to say too much. We're two peas in a pod, our brains and hearts sync up in both the best and sometimes worst ways. My youngest daughter Ella told me that she feels safe when she has sleepovers or playdates with Brody "because she reminds me of you."

I met both Amber H. and Amber V. whilst shooting these sweethearts for magazine stories. I call them my sister wives because we all look so similar.

I became friends with Amber Heard when I photographed her for *Allure* about ten years ago. If I had a little sister, it would be her. I have lived through some super

shitty times with her and lived to (NOT) tell the tale, if you know what I mean.

My other Amber I met eighteen years ago, and from the moment we met, we fell in love and often joke that if one of us had a dick we would be set. Alas. Amber is one of the most consistent, reliable, and honest friends I have, and I can always trust she will tell me the truth without judgment, which is invaluable to me. I encourage you to have at least one friend who you know will tell you what's REALLY up, not just what you want to hear.

There are also many women I've met along the way in my recovery who helped put me back together in ways I could never have imagined. I'm trying to be mindful of the guidelines of my chosen recovery, but I will say that I am 100 percent the product of the many women I met in recovery who loved me unconditionally, taught me about the importance of self-reflection, accountability, friendship, trust, truth, and authenticity. They taught me that a crucial component of friendship is a willingness to be honest and vulnerable. There's that word, vulnerable. Get to know it, get familiar with it, embrace it! Being vulnerable is the key to freedom and happiness (at least according to Brené Brown and me).

My sanity was restored by women who did not judge me and showed me that there are thousands of us who have stories of abandonment, abuse, and addiction. Meeting others with the same damage as I had dismantled a belief system that somehow I was a bad person because I'd had to deal with a long list of scary life experiences. I also learned I didn't need to feel shitty about what happened to me or about choices I made in the past. That kind of support is more than friendship; it is lifesaving.

★ ★ ★

I consider myself a loyal friend, but sometimes friendships get just too toxic or plain crazy to hold on to; and at some point, you have to let go or you will end up getting dragged down. When I was learning how to have friendships, I always had one friend who was just bad news. The kind of girl who would try to fuck your boyfriend or spread a bunch of untruths about you, hoping to alienate you from your friend group. And I've had a couple of REALLY bad run-ins with that kind of girl. Those are people I avoid like the plague. I just don't have the bandwidth for it—I barely have time to shower some days, so there's no place in my life for that kind of crazy anymore.

Not to say that sometimes really difficult things don't

come up within friendships, and I think, *Shit, I don't know if the relationship is going to be able to survive this.* And sometimes they don't. That's the reality. And you have to separate, just like you would from a lover. It's often no less heartbreaking. But for some reason we don't treat the friend breakup with the same sensitivity and understanding. When someone is going through a friend-divorce, few people understand that it's a major loss, the end of something that will never be again, and its own kind of death that you must allow yourself to grieve.

So, how do you maintain these vital female friendships?

Time

One of the most valuable things you can give people is your time, and friendships require time and attention in order to flourish. As I got busier with my family and career, it became easy for my BFFs to fall pretty low on the priority list. Children, partners, work, and maintaining my own physical and mental health all come first, so making time to hang with one of my girls gets harder, but I do my best to find a way to make it happen as often as I can. And I don't always succeed. Without time and attention, friendships, like baking cupcakes, can go horribly

wrong. No matter how profoundly connected you think you are, when life gets beyond busy, making the smallest of efforts to stay in touch can go a long way. I have even been known to send a voice memo as a text, just to let my ladies know they are loved by me and I am thinking of them.

Support

Show up, however you can. Even for a quick hug!

Actions really do speak louder than words. And there are times when one of your tribe will take a beating from life and you will be asked to step up to the figurative friend plate.

Do whatever you can, and know it's not going to last forever and that this is an opportunity to be the kind of friend you would want to have on your own support team.

Be the friend you wish you had. That's what I try to do, especially when someone is in a crisis.

When the shit hits the fan, you really do know who your friends are. Like during a particular marriage crisis when I camped out for a week with the twins at Gwyneth's house.

I was such a mess, good for nothing except weeping endlessly and staring out the window, basically the worst

houseguest ever. She had to take care of not only me, but also my kids, which she did with such love and compassion.

Thanks to her excellent culinary skills, one miserable day I broke ten years of veganism by eating all the homemade sausages she was cooking for our kids' dinner. It's those special moments that stay with you and remind you who is truly by your side.

Trust

Never underestimate the importance of giving someone the gift of trust and safety.

I pride myself on being trustworthy.

Maybe because my life was exploited so harshly by the press when I was a teen, I know all too well what it feels like to have your trials and tribulations made public. Whether your personal biz is blasted all over social media, in the school yard, or in the tabloids, any violation of your privacy sucks bigtime. I try to never betray anyone's confidence. That, to me, is the lowest of the low. On the occasions that I have accidentally let something slip, I am plagued by sleepless nights and disappointment in myself.

Another golden rule: Never, and I mean NEVER ever, fuck a friend's partner. I may have been a cheater in the

past, but it was never with a friend's dude. If anything, I go too far in the other direction, avoiding any hint of impropriety with my girlfriends' partners. I think I border on rude sometimes, but I want to make sure there is not an ounce of confusion about whose friend I am. "I'm with HER not YOU."

Loyalty is something I pay close attention to in my friends. If they don't pass the litmus test of "Will this person try to make a move on my hubby?" I keep them away from my family. They stay in the "social friends" circle, which means that the person is never coming to my kids' birthday parties or a Strokes show or anywhere near my home.

On the other hand, I have besties who if they were butt naked in my yard, I wouldn't so much as blink. I know they would never cross the unspoken "don't flirt with my hubby" rule.

Honesty

There will be times that friends do shit that horrifies you. And then what?

A good girlfriend called me recently and said that she knew that I would be judgmental about what she was about to tell me, but she needed advice.

And she was right.

She confessed that she was having an affair with a guy who was married.

"Does his wife know about this? Is this an open relationship?" I asked.

My friend said the wife didn't know. I asked whether she was going to continue the affair, and she got upset. "I knew that you would judge me about this," she said.

"I'm having a hard time with not having a judgment about this. But shit happens, and I'll do my best to understand your point of view."

I was glad she called to talk, even though I wasn't thrilled to hear her news. Supporting a friend doesn't mean avoiding the truth because it might be hard for her to hear how you feel. Sometimes the most supportive thing you can do is be honest. She wouldn't have wanted me to hide my reaction from her anyway—she knows, and anyone who knows me gets that I am incapable of hiding my feelings.

My friends and I are straight up with each other, which I think is an essential part of an authentic friendship.

I play a game we call "blind spots" with one of my besties. In the spirit of full disclosure, I say to her, "Tell me something I don't see about myself." And she tells me

something about me that I can't see, but that I need to know. Everything from "That dress you wear is not flattering on you," to "You've been very overreactive lately."

Then we switch, and I tell her something I feel she needs to know. This type of sharing allows for extreme vulnerability, but I've learned some insightful things about myself I wouldn't have given a thought to otherwise. Female friendships are a place to practice and fuck up, as well as grow and learn.

Appreciation

The hugest honor for me, and what allows for intimacy in friendships, is when you bear witness to someone's life and allow them to bear witness to yours.

I've witnessed the women I love struggle with addiction, fall in love and get married and divorced, get pregnant and miscarry and then give birth, have affairs both misguided and transformative. Land a great job, then lose it. Move to another country. Survive a health scare. I've seen them go through it, and in watching how they've navigated their lives, I have learned how to better navigate my own.

When you're friends with someone for decades, your

roles in each other's lives will evolve as your lives evolve. You take turns carrying each other through the really rough times. Any time a friend says to me, "I'm so sorry, I'm such a mess right now," I always say, "Don't worry, it'll be my turn soon."

Because it has been and it will be again.

11.

Diets That Don't Work but Do Give You a Bunch of Weird Health Problems (and Other Body Issues)

A few years ago, Chelsea Handler asked me if I wanted to guest host her E! talk show *Chelsea Lately* while she was out of town. I was honored—as the only woman in late-night TV, Chelsea was a huge inspiration to me—so I wanted to say yes, but I was also mortified.

"I can't," I told her. "I weigh two hundred pounds."

"You're going to tell me you're not going to do this because of how you look?" Chelsea was indignant. "You of all people? You can do this."

"I can't go on TV looking like this."

"Yeah, you can," she said. "You got this."

So I agreed to do it. On the day of the taping, I put on not one but two pairs of Spanx. It was like full-body Chinese foot-binding torture. I could hardly breathe, let alone talk.

This is the time when you get to walk the talk, I thought. *This is the time that you practice what you advocate for everybody else, which is that no matter what shape the outsides are in, confidence starts with how you feel about yourself on the INSIDE.*

That might sound like an oversimplification, but it's the absolute truth. You can be your skinniest weight and dying of self-loathing, or you can be pretty fucking good with yourself when you're two hundred pounds.

I went out there and hosted Chelsea's show with my head held high, and you know what? Even though I couldn't really breathe, I killed it. I refused to let the number on the bathroom scale stop me from living. I'd let that happen too many times before, and I wouldn't do it again, not when the stakes were so high. Showing

up and saying yes for that opportunity allowed me to be reminded that I am capable of hosting a live late-night TV show, something I hadn't done since I was eighteen. Stepping outside of my comfort zone in such a huge way reinforced the belief that I am not the sum total of my physical being and the number on the scale, even though the world would have me think otherwise.

But for a long time, I did obsess about my body. In my own defense—in defense of all women—it's no wonder we're so caught up in our appearance. The fact is external feminine beauty is highly valued, and we are constantly given the message that a slamming body is the most valuable thing a woman can possess. The most beautiful girl in the room not only gets the guy, she lands the job, gets better service at a restaurant, rises through the social ranks before her friends. Doors open for the beautiful woman that may not for a female who is twice as smart but half as beautiful.

I wish it weren't true, but I have witnessed this phenomenon play out too many times to deny it. Of course, you don't have to live by this belief system—God knows I try not to—but it's important to understand the rules everyone else is playing by, especially if you want to win at the game of life. Or at least, give a wholehearted effort.

* * *

From the ages of twelve to thirty-five my body, not my mind, was my primary currency. My ideas, my humor, my curiosity—none of those were valued as much as my body, which preceded me into almost every room.

As a kid I trained to be an Olympic gymnast. My schedule was rigorous. Four hours a day, Monday through Saturday, I was at the gym. My body was like a boy's, narrow hips, flat chested, wide shoulders. When I was twelve, I badly injured my ankle and was forced to stop training immediately. It seemed like literally overnight I grew huge boobs and a gorgeous bubble butt. With no time to prepare for this new "me," I was now responsible and accountable for a super curvy figure and had no idea how to handle the effect it had on the opposite sex.

I continued to wear the same clothes as always—mostly T-shirts and overalls. But the changes to my body were plainly visible even in my tomboy attire. One day I was walking down a London street and passed a construction site. Some workers started whistling. I looked around to see who they were whistling at.

"Want to show me your tits?" one of them shouted.

Is this guy for real? I thought, *What makes you think I would show* you *my boobs?*

The power my new body conferred was becoming impossible to ignore. At my boarding school, the required uniform was a shirt, tie, horribly unstylish skirt, and an extra-large sweater. I personalized it—shortening my skirt and shrinking my sweater until it had just the right fit. As if by magic, I could give my teacher a boner by sitting in the front row in my too-short skirt and too-tight school-girl sweater.

I had become the teenage girl whose body made grown women uncomfortable and men salivate. Pretty much every man I came into contact with gave me the side-eye: teachers, cops, waiters and bartenders, shopkeepers, my friends' boyfriends, and eventually their husbands. My body was the first thing that people responded to, and for a girl who felt largely invisible before then, I have to admit I was not upset about it at all.

Adolescence might have been the first time my body drastically changed, but it wasn't the last. It happened again when I was thirty-five, after the birth of my twins. Prediabetes and thyroid issues were just two of the aftereffects of a twin pregnancy. So I did what so many postpartum

mums do. I frantically dieted, hoping to drop the extra weight. But to no avail.

It was a major struggle to lose a single pound. I tried everything, from the Atkins diet to "cleanses" to the keto diet, although instead of burning fat, I simply put on an additional ten pounds and got the worst breath ever. I tried the go-to diet: protein and veggies plus exercise. Nothing worked. And as time went on, I became more and more desperate, so desperate I tried a crazy diet called hCG, which claims to "reset your metabolism," causing you to lose a pound a day without hunger. But you're also not allowed to ingest any fats or do any exercise. Sounds easy, but it's really not.

On hCG I lost twenty pounds in a month and was able to enjoy about a week of fitting into my size 29 pretwins jeans before gaining it all back in half the amount of time it took me to lose it.

It's safe to say I learned from that experience. I am now committed to avoiding the D-word for good. It's become a word that, to me, is more offensive than douchebag, dickhead, or dumbass. *Diet*. I hate that fucking word. I've banned that word from my house; no one can utter it in front of my kids or in my presence without getting shut down immediately.

IT'S MESSY

Accepting my body is an ongoing challenge. The truth is that I miss wearing the many awesome outfits gathering dust in my closet, and some days I'm just not ready to never see my "previous" body again. Even after all this, I was somehow waiting for my body to return to normal until one day a friend said, "What if this is just your new normal?"

Maybe my friend is right. What if a healthy body looks like my body?

I think about that whenever I'm really struggling with how my body has changed.

★ ★ ★

The media rarely shows accurate representations of women, especially the messy parts and the bits that are unsexy and unglamorous. The overall message we're given time and time again is that We Are Not Okay. We need to look like Her. We need to have a life like Her. We need to have Her marriage, Her pregnancy, and it all needs to unfold in a well-ordered, culturally approved sequence. As someone who did it in the wrong order for reasons no one approved of, I can tell you it doesn't have to be that way. No one gets to tell anyone else how to look, how to feel about their body, or how to live. No one gets to write the script

for us. If I believe in anything, it's that we have the power to create our own lives.

So how do we go forward, loving and living in our bodies if we are not the size the world insists we must be in order to be considered valuable or indeed viable?

Let me remind you . . .

Being valued for your beauty alone is not all it's cracked up to be. The power and value of desirability notwithstanding, there comes a time when, even for the most beautiful, it just gets old. We are more than our asses and eyelashes, our teeth and hair.

Ask any gorgeous woman and she will tell you that eventually her beauty overshadows her being seen for the multifaceted being she is. I've known many beautiful women who are smart, accomplished actors and have been mostly denied the opportunity to play complex women. Instead, their careers have been built on playing the hot girlfriend, the hot mistress, or the supermodel who gets murdered. Perhaps being complicated in addition to being beautiful is too much for our misogynistic culture to handle.

In addition to being relentlessly judged for and ranked by our looks, we live in a time when women and girls are

expected to look flawless 24/7. For people in the public eye, the paparazzi have always been out there, but now that we're all madly snapping and posting pictures of each other, the pressure to look great at all times is exhausting and ultimately sets all women up for failure.

Consider the joys of being low maintenance

In some ways I feel fortunate to have grown up in the UK, where the obsession with beauty isn't quite what it is in the States. We did not have blow-dry bars, eyebrow bars, and makeovers in the mall. Affordable nail salons are a fairly recent development, so if you found a way to get a manicure, you were lucky.

If you see photos of me at events, most of the time my hair is in its natural state and my main effort at makeup is lipstick. And lots of mascara. Most likely applied in the car en route.

I also don't subscribe to the expectation that I'll buy something new for every event I attend. A few years ago, I did an experiment: I wore the same dress multiple times over a six-month period to red carpet and other events. I just switched up the bag, shoes, and jewelry. Guess what? No one noticed, or gave a shit. Whether it's a fancy event or just going to work, the same pressure exists for women

to have a perfect mani-pedi, perfect hairless body parts, dyed and straightened and shiny hair. I find it exhausting and will never wind up on anyone's "best dressed" list because I just don't care enough to compete. I will not participate in competition culture. Which woman wore what gown best? Can't we just say they both wore it great and there is room for everyone to kill it in their chosen outfit?

Unless your body type is naturally thin, being skinny isn't all it's cracked up to be

As someone who's been thin and miserable, I can tell you that the whole "nothing tastes as good as skinny" line is a bullshit myth, along with these gems:

1. **Being skinny guarantees your life will be successful and full of love.**

2. **Being "not skinny" (everything from normal to curvy) means you're lazy, undisciplined, and worthy of neither success nor love.**

3. **It's better to be skinny and mentally unstable than accepting of your imperfect human body and healthy.**

The truth is that when I've been at my thinnest I've also been my unhappiest. Once, after a particularly shitty breakup, I was so distressed that all I ate for two weeks were broccoli florets and soy milk. But I was thin and people would say, "You look AHMAZING. What are you doing?"

What I wanted to say was, "I have a violent boyfriend who got arrested, and he's in jail, and I am completely strung out because I'm obsessed with not being with him anymore, and I can't eat." But I just avoided answering because the truth was too hard to share.

As a photographer I've been known to not photograph girls who are obviously underweight. Sadly, the same courtesy has not been extended to me regarding my curves.

I was photographed for a major fashion campaign not long ago, and it was obvious that my boobs and ass weren't going to fit in any of their sample clothing. I eventually squeezed myself into a dress that fit me like a second skin. When I saw the finished pictures, my boobs and butt had all but disappeared. I politely asked that they put my T&A back where they belonged. I was told it was the first time a subject had ever asked to be "made bigger."

"I didn't ask to be made 'bigger,'" I replied. "But could

you please just put my body back the way it is? We will all be embarrassed if you don't make me look like me."

After many years navigating my shape and the "problems" my body has caused other people, I've committed to never allowing anyone, including myself, to make me feel bad about ME.

Refuse to be body shamed

My boobs, which have breastfed three children for a total of three years, are healthy and thankfully free of any conspicuous lumps. My husband is mildly obsessed with them, as are my cats, who like to lie on them at night.

And yet, if I wear something low cut or tight, they still cause some chaos.

I've gotten used to people talking about my boobs as if I'm not attached to them. At lunch recently, a girlfriend looked at my boobs and said, "Wow, your boobs are massive."

"Up, up. My eyes are up here." Talk to my face, not my tits, please.

But here's the deal with the boobs.

Finding an attractive, comfortable 38E bra is all but impossible.

My back aches most of the time.

Big boobs size me out of most of the clothes I want to wear.

They've made finding clothes that fit my figure a full-time job.

I've been told by more than one saleswoman to just give up and go shop in the maternity department. (Uh, no thank you, I've shopped in that department before, and I'm not going back.)

Now I mostly shop online. I can try things on in the privacy of my own home without shame, or needing to call for help when I get stuck inside a dress, which is a frequent occurrence when I shop in a store.

I feel the worst about my boobs when I'm the subject of a photo shoot. On a typical shoot, to avoid confusion or embarrassment, I share my exact measurements with the stylists who are tasked with finding outfits. I reach out ahead of time and warn them that like most nonmodel women, I am not sample size—nowhere close, actually—and they will need to be creative with my wardrobe. I give them a list of designers whose clothes generally fit my body, as well as styles that have been successful in the past. I try to make all our lives easier, because I have a good idea of what's coming.

One particular shoot, I showed up to find that the

majority of outfits were at least two sizes too small. There was one mumu that I refused to even touch. There may have been a few good bottom halves but the tops were a disaster. Thin-strapped tank tops, crop tops, and men's baggy white blouses. All terrible. What did fit was a fluffy white oversized sweater.

I politely asked the stylist if she received my email with my measurements.

She said she had seen my email, but instead of acknowledging that she hoped if she ignored the numbers they would go away, she said, "Let's just try a few things on." To which I said, "Please, there is nothing to be gained from me trying on things that are two sizes too small, except that I will feel upset."

So she suggested I just wear the fluffy Marshmallow Man white cardigan. With no pants. No pants is always the go-to idea. In fact, if you see a woman on a magazine cover wearing no pants and it looks as if her top is meant to conceal larger-than-acceptable boobs, it's either me or someone like me.

I put on the cardigan, looked in the mirror, and saw that I looked exactly like a giant snowball about to get rolled downhill.

And then it happened. I started to feel bad about my

body. The stylist might have had other ideas, but now it was too late. The negative voices in my head were getting louder, drowning out suggestions. "You are causing a problem with your big boobs, Amanda, they are messing up this shoot, everyone is frustrated with you because nothing fits you, you should really lose some weight, make your body smaller, shrink those boobs, get a breast reduction, go on a diet, take some pills so you aren't hungry, get a Lap-Band, anything, hide yourself away so that your body doesn't cause any more problems."

That was when my more evolved self took over, as it does most of the time these days.

I repeated my self-love mantra: *I am not my boobs. I am more than a body. I am more than a dress size. I do not have to wear the only thing that fits me to keep a stranger happy. This is not my problem.*

I breathed deeply. And then I spoke up.

"I'm sorry you didn't take me seriously when I said I was a size 16, with 38E boobs. But it's true, and it means I don't fit into the things you chose for me except that lovely white snowball cardigan, or that hot mumu, which would have been wonderful when I was pregnant with my twins."

She looked at me somewhat confused and maybe embarrassed that she'd ignored my email, but now I was put

in the position of feeling bad for *her*, and for a moment I regretted having been so direct. But seriously, why didn't she just do her job? Why didn't she read the email, google me, for God's sakes, see what she was dealing with and find me some appropriate clothes?

I had to fight hard within myself to not go down the rabbit hole of shame over something that was not my fault and should not be a reason to feel bad about myself. Maybe the next time I do a shoot, I'll just bring my own clothing with me. That way no one will feel bad, and most important I won't have to feel bad about my glorious, healthy boobs.

Body acceptance

It's better to accept yourself and your body than to beat yourself up. It's better to feel good and healthy at a heavier weight than to feel like shit despite being ten pounds lighter. It's better to be body positive than body negative.

Body acceptance isn't something that comes easily or naturally for many of us. You get there one small step at a time. Telling women to love their bodies is a high bar to set right out of the gate. Show me a woman who can one day wake up and decide to love every part of herself, after an entire life of receiving the subtle and not so subtle

message that however she looks is just not good enough—
"Sure, I'm down with those stretch marks across my belly
and the saggy skin on my upper arms!"—and I'll show
you a woman who's either drunk or lying.

A good first question to ask is, Why are you unhappy
with your body?

Is it because you want to be your optimal physical self?

Or is it because looking at a bunch of bikini selfies on
Instagram makes you feel like shit?

Defining and getting honest about the root of your
body shame is crucial.

You've got to get real about your genetics, about the pros
and cons of what you were born with. I have what some
consider an "enviable" hourglass figure. Big boobs, small-
ish waist, decent-sized bum. But I've also had to come to
grips with the fact that my arm bones are as big as some
girls' leg bones.

You can spend your entire life fighting that, or you can
accept what's going on. Go to your happy place, and ask
yourself at what weight were you happiest. Can you get
there with *reasonable* diet and exercise, by which I mean
a regime that doesn't consume you and become your pri-
mary obsession in life?

Something else to remember: Our culture's definition

of beauty changes with the seasons. Women drive themselves crazy trying to fit into one very small bucket. I've always believed that I was born in the wrong era. At least curves have partly come back into style. Thank you, Kim Kardashian. (Love her or hate her, you cannot deny that she paved the way for the acceptance of the curvy girl.) By the time this is published, however, the "curves are in" phase may have passed. What does this tell us? That there's no point in beating yourself up about how you look. Next year your exact body type might go from being undesirable to the physique everyone covets.

I would like to propose something radical: Instead of being consumed with looking like someone else's ideal of beauty, why not ask yourself, "What do I consider 'beautiful?'" It's been so ingrained in us to seek out some mass-produced standard of beauty that in truth you might not actually give a shit about what everyone else thinks is "beautiful" when you stop to consider your own standard.

Although we're still stuck inside a system that values our exterior much more than our interior, we can expand the notion of what is desirable. And that can begin today, with the conversation we're having right now.

12.

It's Never Okay

***Trigger warning**

1. **When I am five years old, a man flashes me whilst I'm eating breakfast in my family kitchen.** Sticks his flaccid pink penis up against the kitchen window. Really puts me off my full English breakfast of eggs and bacon.

2. **When I am twelve years old, a man I called The Toad jerks off under the desk sitting across from me (see story on page 189).**

3. **When I am thirteen years old, Tom, a boy five years older than me, pushes my mouth onto his dick.**

4. When I am fourteen years old, a guy sitting next to me on the Paris Metro silently jerks off onto my leg.

5. When I am fifteen years old, I'm making out with a guy I'll call Paul in his dormitory bed. I tell him I've changed my mind and I want him to stop. I am drunk, the room is spinning. I want to leave, and try to. But he forces his penis inside me anyway. The next thing I remember is regaining consciousness and the sun is coming up, then walking through a field with my clothes ripped and unexplained scratches. I drag myself to the railway station and take a train back to my mom's house, where I never tell her what just happened but instead sneak into my bed and hope that when I wake up this will all be a bad dream. For many years I believed being raped was all my fault. For being drunk, for getting into bed with him, for changing my mind. It never occurred to me that when I told him no, he should have stopped. My shame was suffocating, insidious, and emotionally stalked me for the next twenty years.

★ ★ ★

IT'S MESSY

The Toad Man, aka Frank Wank, was my initiation into the way females are abused—sometimes overtly, but most often subtly, quietly, secretly, carefully, and repeatedly.

In the midst of their shitty divorce, my parents would leave me with Lulu, a pretty young neighbor girl who also happened to be a heroin addict. There was no way my parents could've known; she hid it so well with her fancy English accent and expensive clothes.

When she needed extra money to buy drugs, she would moonlight as my part-time babysitter, and I would have to tag along and do whatever she was doing.

Some weekends were pretty standard kid activities, but other times Lulu would take me in a cab to a big, fancy apartment in Belgravia, where a busy lady assistant would give me a pink fizzy drink and tell me to sit outside a closed door in the hallway and wait. Lulu would then go into the room for a short time before reappearing, and we would take another black cab back to her house, whilst she counted the thick wad of cash in her grubby hands.

One day, on our way to the fancy apartment in Belgravia, Lulu asked if I wanted to go into the room with her instead of waiting in the hall. I nodded my head okay, but had no idea what I was agreeing to. We arrived at the

apartment building. As I had done many times before, I stepped into the still, vast entryway of the building. We took the elevator to the penthouse, and when the doors opened I smelled the usual smell of men's cologne and cigars. The same lady handed me the customary pink fizzy drink, but suddenly I felt nervous and wanted to go home.

"What do I have to do?" I asked.

"Nothing, just go in the room," she said.

I turned the door handle and walked in.

A man who looked like an old toad sat behind a big desk.

He was stocky, his skin was bumpy, and he wore a dark-brown silk robe.

"Sit down and tell me about yourself, Amanda. How was your day at school?"

I sat down on the other side of the desk. I was wearing my school uniform, a navy-blue pleated skirt, white shirt, tie, and sweater. How did he know my name? And what else did he know about me? Did he know I was only twelve, that I was a smart but curious girl, that my parents would cry if they knew what he was up to?

I answered his question. Then another and another

until finally he stopped asking questions, just like that. I felt weirdly uncomfortable and embarrassed but was relieved to be told I could go.

Later I would learn to identify that feeling as shame.

On the drive home, my babysitter counted the money, as usual, except this time she handed me some crumpled-up notes. I stared down at the bills in my hand. I had never had so much money in my life, and I wasn't sure what I'd done to earn it. After about three or four visits, I finally figured out that The Toad, as we called him, was jerking off behind the desk. I told my babysitter I wouldn't go back. This was a lesson that brought me close—too close—to the kinds of sexual exploitation that women and girls face every day around the world.

<p align="center">★ ★ ★</p>

I've thought long and hard about the difference between "mild" sexual assault—the guy exposing himself outside our kitchen window, the guy jerking off on the Metro—and severe abuse. Flashers could be considered slightly comical. I mean what kind of wacko exposes his penis to the elements like that? I also once saw a guy sitting in his car with his pants pulled all the way down stroking a big

boner. When he saw my look of horror, he laughed and then proceeded to drive alongside me pulling his penis and smirking at me.

I arrived instead at the same conclusion as my writer friend Kelly Oxford, who, after Donald Trump bragged about assaulting women during the 2016 presidential campaign, launched the #itsnotokay Twitter campaign. Before the week was out, she'd received twenty-seven million views and replies to her invitation for women to tweet her their first assault.

First assault, yeah, that's the world we live in.

Kelly went first: "Old man on city bus grabs my 'pussy' and smiles at me, I'm twelve."

Women tweeted stories about guys rubbing their dicks against them in pretty much every form of public transportation out there. At department stores and office parties. At sports events and family gatherings. Seriously, if you didn't know better, you would think that dudes spend most of their days running around rubbing themselves against young girls. Women wrote about being assaulted by coworkers, uncles, husbands.

Here's the thing: You don't have to explain anything. You don't have to apologize. For coming home at night

on the bus. For going to a party where dudes are drinking, or where YOU are drinking. For wearing a miniskirt to the all-night market to pick up almond milk or just for being a woman in the world. It's never okay to be assaulted in any way, ever.

13.

Pain Is Not Without Purpose

I struggled with postpartum depression after Ella and Silvan were born and throughout the first two years of their lives. I remember feeling as if I'd given so much of myself to everybody else that I literally had no identity of my own.

As unsure as I was about what was going on with me, I knew instinctively that I needed a room of my own if I was going to rebuild my fractured sense of self. I didn't have a spare room available, so I bought a busted-up shell of a 1950s Airstream trailer for nine hundred bucks, parked it

in my front yard, furnished it with a bed and a desk, and began the process of reconnecting with myself.

I loved that Airstream. It was my private space, off-limits to everyone else.

One of the best and worst things about family life is the obligation to share everything—every decision, every activity, every outing. You can't hang a picture on the wall without asking "Hey, how do you feel about hanging this picture on the wall?" You have to consult about the thread count of the duvet cover, about what's for dinner, about whether it's okay to turn on the heat or the air conditioner. But being inside my little trailer, in the stolen moments when I wasn't breastfeeding, gave me a much-needed respite from all that, and the space to remind myself of what I liked, what I was passionate about, and over time I was able to ask myself what I felt creatively motivated to do, other than sleep and snack.

I didn't know the answer to that question, but I knew it had to be something that reflected my value system and would benefit people other than just me. It had to be so compelling it would motivate me to get out of bed in the morning, something that was a major struggle at the time.

★　　★　　★

Front and center was my struggle with postpartum depression. I had trouble finding helpful resources, and I couldn't understand why it was so hard to get honest accounts of surviving postpartum depression. Even my internet searches were mostly unfruitful. I would often find cookie-cutter descriptions of what I was going through on some "medical" websites, but clinical terminology didn't provide a lot of solace. You would think that it would be easy to find real-life stories about PPD online, and yet I found very few that I could relate to. I wondered why women were so reluctant to share their experiences of an affliction that affects so many of us (PPD is believed to affect up to 20 percent of women who give birth each year).

This was the first of many moments when I saw a need for honest, accessible, and relatable information that would reassure women like me that they were not alone. This realization dovetailed with my philosophy that even the shittiest of experiences can bring something positive. (I had learned this firsthand many, many times.) When you make yourself of service to other people, you are allowing for the possibility of turning every fucked-up thing that's happened to you into a gift. Your pain is not without purpose. And, through the process of helping someone else heal, you'll often find you are also able to heal yourself.

I also couldn't overlook my deep desire to find a way to facilitate a dialogue that would allow women to identify their own experience through someone else's story and in doing so, feel less alone. I wanted to shine a light on diverse voices, and give women whom we *think* we know the opportunity to share their stories in their own words. I'm sure that impulse had something to do with the fact that the tabloids seemed to own my story for many years of my life. If there's one thing that unites human beings, it's wanting to feel seen and understood for who we really are. I began to envision something that would replicate the conversations happening in my home, with my friends talking about real-life struggles, no matter how messy or strange or unconventional. Unplanned pregnancy, abortion, miscarriage, childbirth, heartbreak, sexual assault, divorce, getting fired, getting cheated on, going broke, all the hardships that so many people experience can actually provide the tools we need to help someone else survive the same moments.

At first I thought this platform for women would exist only online. I googled how to make your own website, but there were very few tutorials back then, so I taught myself basic code at night when the twins were sleeping, built a simple blogging site, and started writing posts about what

really happens to your body after having a baby and about the challenges I was having with PPD. I'm not sure how it happened, but people started reading the pieces I wrote. A community began to grow and soon women from all over the world who were also seeking answers started to share their stories and experiences as well. That was the moment the first incarnation of *The Conversation* was born.

Even though the blog was gaining momentum, I knew there was a missing piece that could allow the stories to reach more people. I just wasn't sure what it was right away. It occurred to me that with my experience as a photographer I already knew how to use my still cameras for video, and I knew how to light a person, so what was stopping me from interviewing friends about all the subjects being discussed on the blog, but from my own living room? I would set up the cameras myself and then have a friend hit the record button.

Those first interviews were really low-budget DIY productions. I am forever grateful to my trusting and brave friends who agreed to be a part of the first *Conversation* interviews. Actress extraordinaire and one of my oldest friends Minnie Driver was the first woman to sit down with me and discuss what it was like to be a single parent,

followed by Kate Bosworth, who talked about body image, and Christina Applegate, who so honestly shared her story about being a breast cancer survivor. The footage was powerful, raw, unique, and everyone who watched it was affected by the level of truth shared from these women who were usually so protective of their private lives.

Over the next couple of months, whenever I had the energy and money to do it, I would interview a woman about what was important to her and what she had learned through personal hardship. I wasn't interested in the superficial stuff like who she was sleeping with or what she was wearing . . . and that was evident in the kind of questions I asked and the answers I was given. When you are seeking answers yourself, it's not hard to come up with questions.

The point of *The Conversation* was to connect women around the world and to let them know that sure, the outfits, zip codes, and skin colors might vary, but if you're identifying as a woman, these experiences are universal and all too familiar.

★　★　★

The Conversation premiered on Lifetime in spring 2012, and I was fortunate to interview some of the most iconic,

smart, insightful women on the planet. Jane Fonda, Lady Gaga, Zoe Saldana, Gwyneth Paltrow, Arianna Huffington, Sarah Silverman, and Alicia Keys sat on my living room couch and shared stories about their loves, losses, successes, and failures.

Jane Fonda was one of my favorite interviews ever. Younger women don't always look to older women for advice—they are in different life stages, and there aren't always opportunities for different generations of women to meet or spend time together. But Jane is a pioneer for all of us; she has been producing her own content since the '70s. While she's most known for her acting, she's also a feminist, an activist, a producer, and just an all-around beautiful, sexy, and smart woman. I mean—she sets the bar high for being a badass well into the final chapter of life.

I also wanted the show to offer solutions. I asked my guests how they had worked through their issues, how they'd come out even better on the other side. My question was always *how*? How did you recover from your breakup, your depression, your addiction? Tell us what worked for you.

In each interview I aimed to ask the questions that would help people most. And that's what I told everyone

when they sat down. They'd inevitably ask, "What are we gonna talk about?" And I'd say, "Your only goal is to think about the person that is watching this and how you can help them with what you're saying. So you tell me. What is the thing that didn't kill you but made you stronger? That's what I want to talk about."

Lady Gaga talked about sex and how it sucked when she was a teenager but got better as she got older, as well as addiction and self-harm. Portia de Rossi talked about the time she wasted obsessing about her weight and the shape of her body, and how hard it was for her to come out as a gay woman because she had no role models. Olivia Wilde talked hilariously about how she tried to save her previous marriage by endless house remodeling; asking for a divorce was the scariest thing she'd ever done, she said, but as much as admitting failure made her feel flawed, it also made her feel human. Miley Cyrus talked about the power of realizing that you don't actually have to smile all the time, and the fear people feel when a woman expresses her true self. Sarah Silverman talked about "the bravery of just existing" as a way to survive depression.

The show was honest but not salacious. I refuse to do anything clickbaity just to snag viewers. Our culture has been feeding people that kind of shit for so long. If you

feed someone McDonald's her whole life, that's what she's going to want. Start giving her a home-cooked meal, and the taste for McDonald's disappears. But it's hard to get the home-cooked meal in there. Our viewership numbers never reached *Real Housewives* levels, but our audience was ardent and loyal.

I had no idea that an interview show could affect so many people in the most intense and powerful way. I cannot tell you how many emails similar to this one I've been lucky enough to receive.

I'm writing to say THANK YOU to Amanda for creating *The Conversation*. I discovered it when I was going through an excruciating breakup and it honestly saved my life and inspired me to keep working towards my dreams and gave me the hope I desperately needed. This series is everything to me and exactly what I needed when I couldn't find anything to make me feel like things would be ok. THANK YOU.—Jessie

I have met the most extraordinary females all over the world who watched *The Conversation*. But for some reason Whole Foods and CVS seemed to be the spots where

I would run into viewers most frequently. Women would approach me, apologize for bothering me (NEVER A BOTHER), and whilst my kids ran rampant around the store, they would share their story about how this or that interview had changed their life in some incredible way. I thought that nothing could get any better until Hillary came along . . .

<p align="center">★ ★ ★</p>

Interviewing Hillary Clinton was the dream of a lifetime. I've admired her since she was First Lady twenty-four years ago, and I made it my mission to interview her. When she announced she was running for president I thought, *This is my chance.* I was badly counseled that I should wait until after the primaries, but I ignored all the advice and put in my interview request—and thank God I did.

Let me tell you, I went to every single person I knew who had any connection to her in any way—even I was surprised at my tenacity. I was relentless and determined in a way I hadn't been in years. It was both the most exciting and the scariest day of my life when I received the call that the interview had been confirmed; Hillary was in.

I began to research obsessively. I downloaded her au-

diobooks so I could listen to her tell her stories. I wanted to familiarize myself with her voice, her vernacular, her cadence. I wanted to learn about her in every possible way. I watched all her long-form interviews from the last thirty years, looked at pictures of her, saw all her notable news conferences, played and replayed all her most famous speeches, like her Beijing "women's rights are human rights" moment. I just saturated myself in all things Hillary until I felt confident that I would no longer feel nervous sitting next to her and I could take the conversation wherever she wanted it to go because I had fully studied her incredible life.

The interview was more than I could ever have hoped for. Even though I never believed any of the misogynistic crap aimed at her by opponents and haters, I was a little surprised by just how warm and down-to-earth she was, and how easy she was to talk to.

And we really did talk. I wanted to know how she got to be such a badass. I asked her about the influence of female role models in her own life.

"Your mom had a very traumatic childhood," I said to her. "How did that impact her ability to mother you?"

"That's a very smart question," she answered.

If there was ever a perfect moment in my life, to have my self-worth fully validated by another person, that was it.

Then to my amazement, Hillary asked me for my advice. "Maybe you can help me with something?" she asked with a smirk, letting me know she was in on the joke. She then talked about the fine line a woman in the public eye—a woman running for president—must always walk. She should listen to what people say about her, accept criticism, and respond to it without falling into the stereotype of being "an emotional female."

I don't know a woman alive who doesn't feel she has to walk that same tightrope on a daily basis. In that moment I was reminded once again of the many ways in which we are all connected. Everyone faces challenges on the path to success, and as women, we face many of the same ones. There is not a job, relationship, body, or lottery win that gives you an exemption from that.

★ ★ ★

The Conversation helped pull me out of my postpartum depression and gave me a purpose. But the reality remains that as far as women have progressed, it's still hard for a female who isn't easy to categorize to be hired into the

mainstream. After my Clinton interview, I was invited to take a lot of meetings. I met with some baller executives, including one who sat me down and told me she thought I was one of the best interviewers of my generation. "I wish I could give you a job," she said. "But I don't know where to put you. You're not traditional news." I went to a meeting at CNN. I went to meetings at NBC, MSNBC, CBS, HSN, Vox, and *Vice*. You name it, I went there. It was all a variation on the same theme: Yes, they said, we can see that you're talented, but we just don't have a place for you.

So, not suitable for news because I like to say fuck, but also not right for E! because I don't care what people are wearing or whom they are sleeping with.

I will admit that my ego and my spirit took another big hit. But soon enough my desire to thrive kicked in, and yet again I reminded myself that perhaps rejection was God's protection, and that being unemployed had historically allowed me space to dream up something magical, like *The Conversation*. Sure enough that's exactly what happened, and less than a year later I launched #Girlgaze, my new media company for girl creatives.

You see, I know without a shadow of a doubt that the times I've trusted my instincts and been willing to risk failure one more time are the times when I have succeeded.

Take the risk, no matter what anyone else tells you. The worst thing that can happen is that you fail, again, and so what? Failing is part of succeeding. If someone has never failed at anything, that tells me they've never really risked anything.

So, as I continue to do on an almost daily basis.

Please try, and if you fail, try again.

And again.

And again.

And maybe even again.

Never give up, because if you don't get up from off the ground after another failure, you'll surely miss the miracle when it comes.

About the Author

A MANDA DE CADENET is a creative force with a lifelong career in the media. She began as a host on British television at the age of fifteen and became a sought-after photographer shortly after—as a result her impressive photography career already spans nearly twenty years. She is the youngest woman ever to shoot a *Vogue* cover and has photographed many of the most influential figures in popular and political culture.

As a media entrepreneur, Amanda is the creator of *The Conversation*, a series that showcases her in-depth interviews on real topics with celebrated women. Whether it's in conversations with Lady Gaga, Sarah Silverman, Zoe Saldana, Chelsea Handler, or Gwyneth Paltrow, or in

discussions with devoted followers of her social channels, Amanda consistently delivers an honest and authentic voice. The series has aired in eighteen countries and is featured online, with over ten million viewers. In January 2016, Amanda conducted an exclusive one-on-one interview with presidential candidate Secretary Clinton.

In February 2016, Amanda launched #Girlgaze, a digital media company utilizing user-submitted content and highlighting the work of female Gen Z photographers and directors. #Girlgaze is dedicated to closing the gender gap by creating visibility and tangible jobs for girls behind the lens. With over one million submissions and counting, #Girlgaze has expanded into original content, IRL events, and EComm.

Twitter: @amandadecadenet
Facebook: @amandadecadenet
Instagram: @amandadecadenet
Website: www.amandadecadenet.com